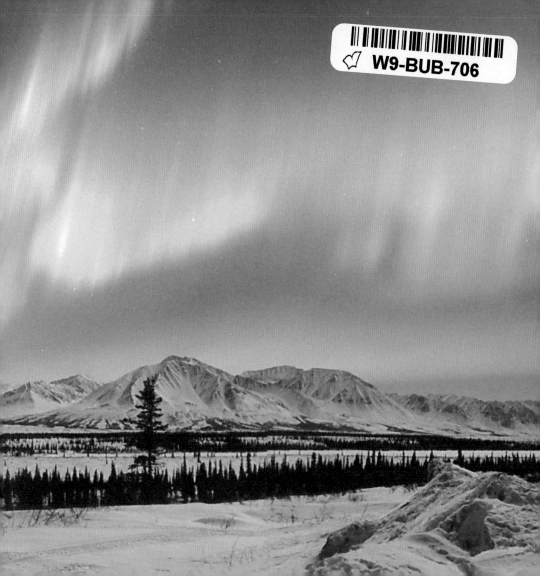

W9-BUB-706

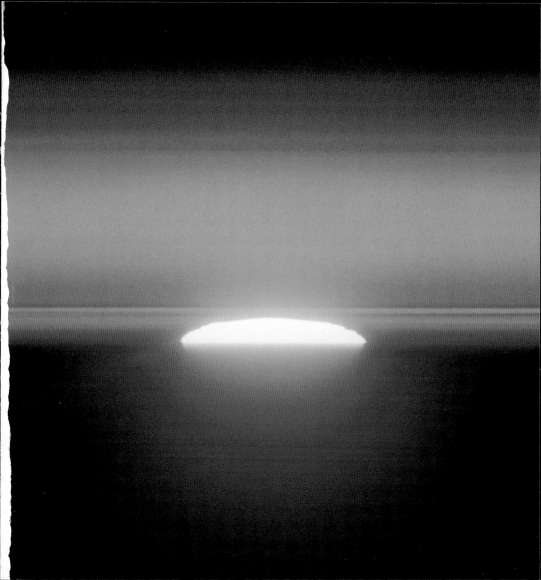

The # **Sun**

Steele Hill | Michael Carlowicz

, New York

For Elinor Hill, the mother who inspired me to create something from nothing and to transform experience into art. —SH

For Rachel, Samantha, Michael, and Thomas:
One generation passes away, and another generation comes: but the Earth abides forever. The Sun also rises. ECCLESIASTES 1:4–5
—MC

Contents

The Sun You Know and the Sun You Don't

Busy old fool, unruly Sun,

Why dost thou thus,

Through windows and through

curtains, call on us?

John Donne, "THE SUN RISING"

The Sun rises over the limb of Earth for the astronauts of space shuttle mission STS-101 in May 2000. The light silhouettes the tail of the shuttle *Atlantis* and illuminates the razor-thin atmosphere that keeps the planet habitable.

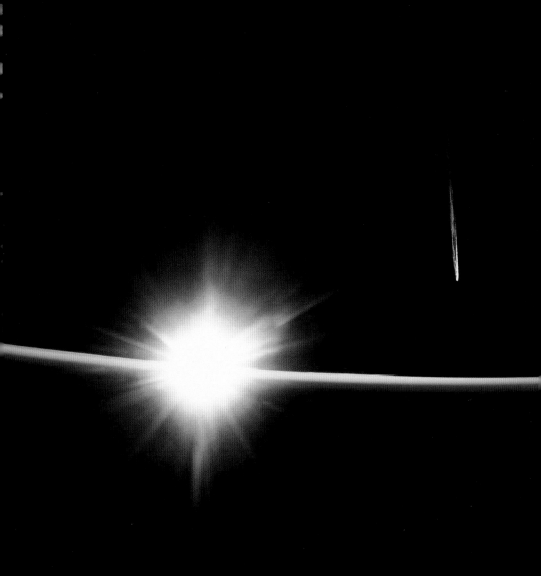

AFTER ALL THESE YEARS, we think we know the Sun. It is familiar and ever present, central to human culture. It's so familiar that most of us hardly look at it and so brilliant that we cannot. We all know what the Sun looks like . . . or do we?

We have spied it in the sunrise and sunset—the only times most of us can view our star without going blind. But have you ever considered the view from space? What do the astronauts and satellites see? The Sun rises once every twenty-four hours if your feet are on the ground; it comes up 16 times a day (every 90 minutes) if you live on a space station. It never sets on the satellite known as the Solar and Heliospheric Observatory (SOHO).

We have all watched the sunbeams settle through the trees, but how many of us think of the Sun when we see auroras? Long after nightfall, the reach of the Sun can stir up Earth's atmosphere until it swirls with ghostly rays of light.

Clouds may cover up the Sun, swallowing it up in a midday thunderhead. But it's still there, just as it is still present when the swirling clouds of solar wind blown aurora puff up to eat the Moon (see page 21).

From the ground, we can see pillars of light stretching out of the sunset; from space, we can see massive balloons of electrified gas erupting across the solar system. Rainbows tease out the color of sunlight, while telescopes can tune in to one or all of the colors of its electromagnetic spectrum.

Wars have been waged and halted because of events taking place on the Sun; emperors and kings have been crowned and crushed in its light. As far back as you can go into history, the Sun has been the center around which all life revolves. Food, rhythm, energy, light. And these practical gifts have sometimes morphed into supernatural ones, as people have observed the cycles in the sky and seen hints of universal order and divinity.

This book reveals the Sun in a whole new light. There is a Sun we know—the one we draw in our kindergarten classrooms and capture in our sunset photos while on vacation. And there is a Sun most of us do not know, unless we've been spending too much time out of the sunlight in the library, the observatory, or on the Internet.

The next few pairs of images depict the Sun in ways familiar and not so familiar. The story of our Sun is told not just by the daylight but by the night sky; not just by its full brilliance but also its reflected, distorted, and bent light; not just from Earth, but from the edge of the solar system.

The Sun sets in Halifax, Nova Scotia. The Sun appears much larger when it is near the horizon due to the "Ponzo illusion." Your brain interprets the Sun as being farther away than when it is directly overhead, but the objects in the foreground—trees, mountains, etc.—make it seem closer and larger.

→ Two prominences curl off the southeastern and southwestern hemispheres of

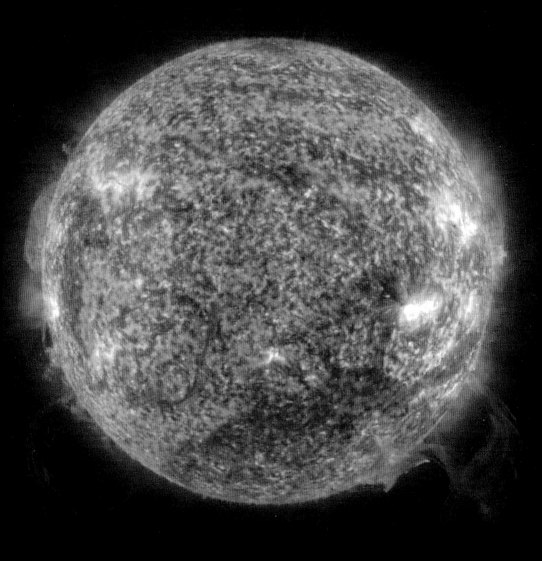

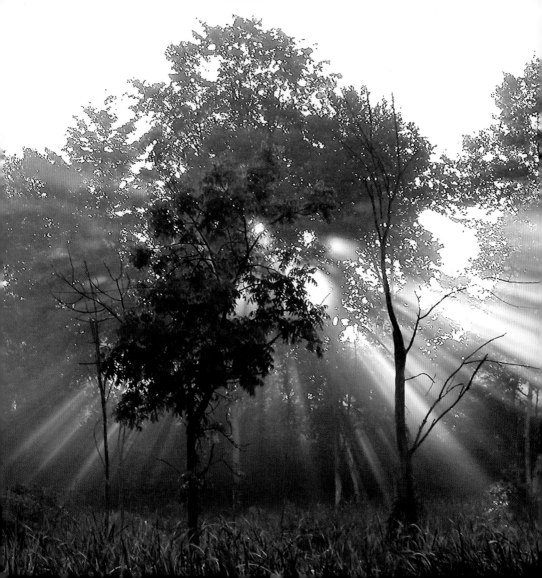

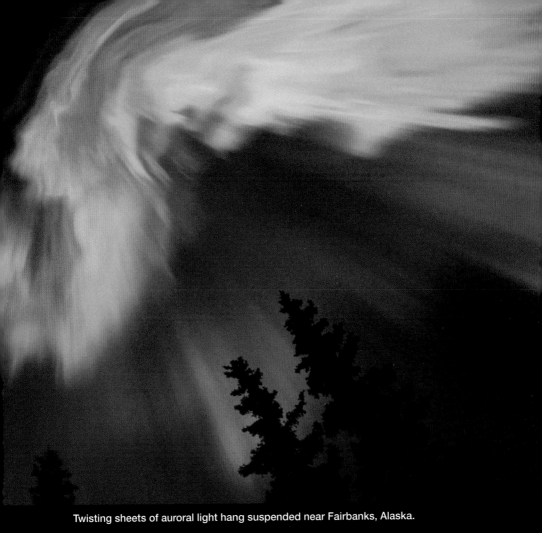

Twisting sheets of auroral light hang suspended near Fairbanks, Alaska.

← Dawn's sunlight streams through the mist and trees in Ontario, Canada.

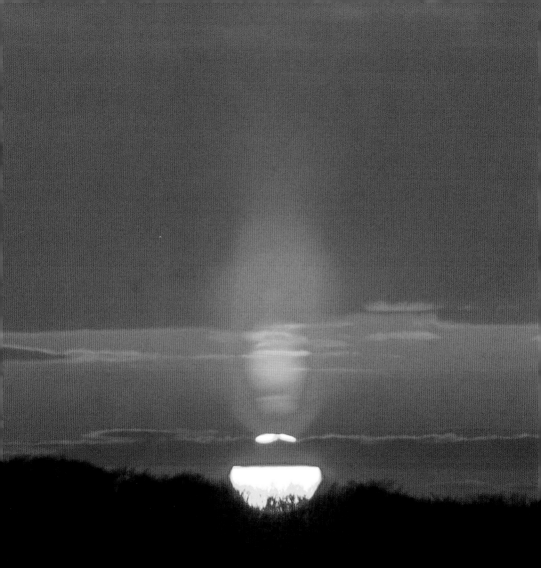

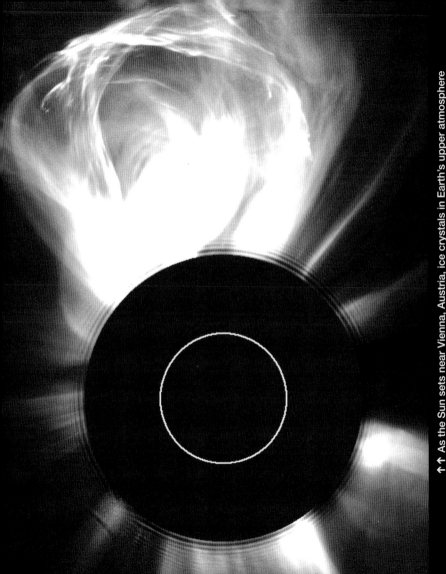

↑↑ As the Sun sets near Vienna, Austria, ice crystals in Earth's upper atmosphere form a column of sunlight—a sun pillar—stretching out from the solar disk like a flame above a candle.

↑ A powerful solar storm—solar physicists call it a coronal mass ejection—blasts off the Sun on February 27, 2000. The image was captured by using a coronagraph (an instrument that creates a false eclipse) on the SOHO satellite.

15

This whimsical hand-drawn sketch of the Sun graced the title page of a seventeenth-century manuscript entitled *De thermis Andreae Baccii Elpidiani, civis Romani* (*Of Temperatures, by Andrea Bacci of Elpidanus, a city of Rome*).

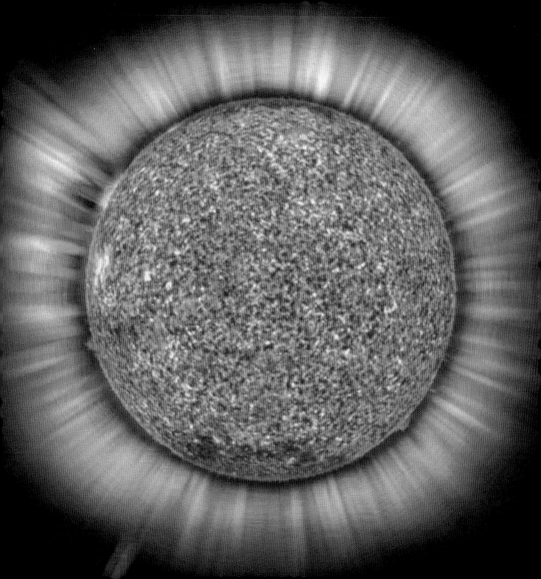

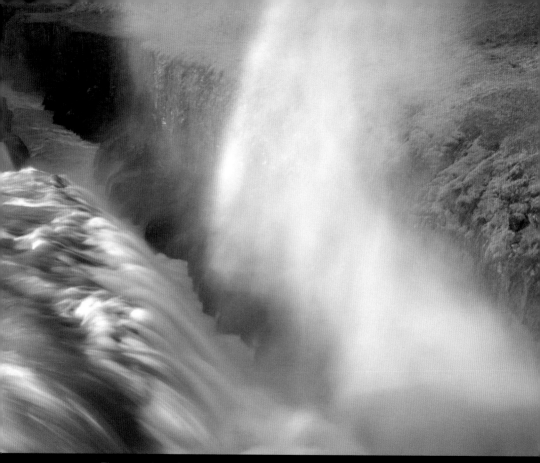

The spray from Gulfoss, the "golden waterfall" in Iceland, acts as a prism teasing out the rainbow of colors in sunlight.

→ A spectrograph reveals the distribution and intensity of colors of visible light reaching Earth from the Sun. Gaps, or black lines, in the spectrum represent colors that were absorbed by atoms on the Sun. These "absorption lines" tell scientists which chemical elements are present on the Sun.

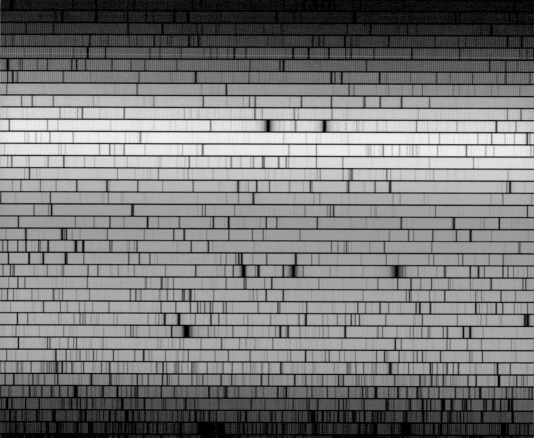

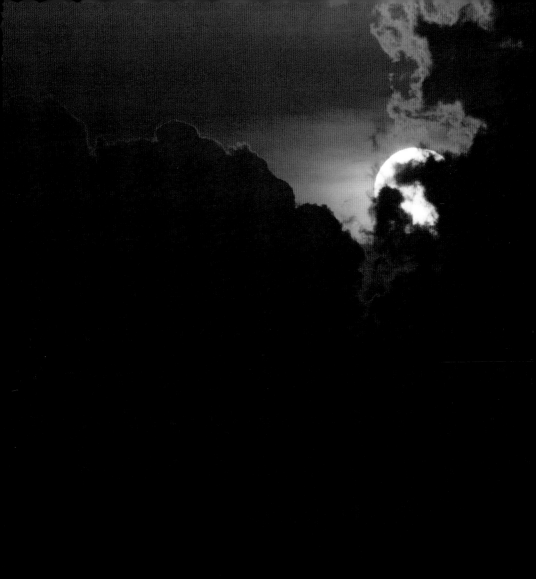

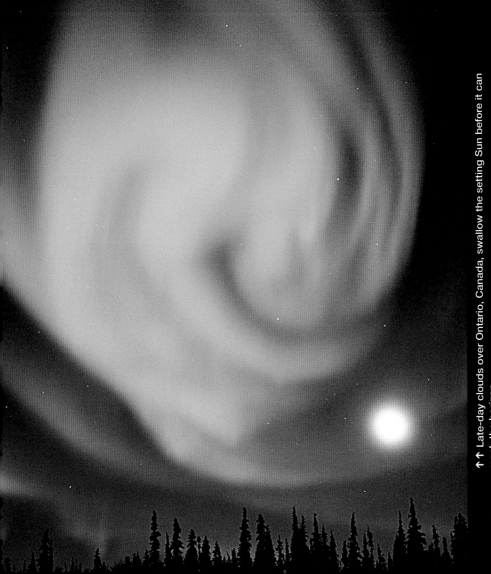

↑↑ Late-day clouds over Ontario, Canada, swallow the setting Sun before it can reach the horizon.

↑ A serpent-shaped aurora prepares to eat the Moon over northern Alaska.

21

The Sun King

The Sun, with all the planets
revolving around it, and depending
on it, can still ripen a bunch of
grapes as though it had nothing
else in the universe to do . . .

Attributed to Galileo Galilei

A sunrise in Finland is obscured by passing clouds.

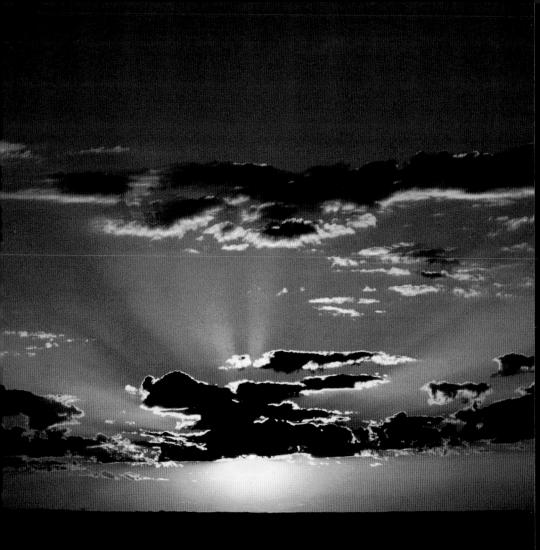

THE SUN IS ENERGY. If you want to be technical about it, the Sun discharges 386 billion billion megawatts every second. More energy is released in a solar flare than we'd need to power the United States for twenty years. But really, the Sun's energy is a bit more complicated than that.

Though it sits 93 million miles away—and its light takes eight minutes to reach our planet—the Sun dominates life. It's an object of worship; fuel for plants and animals; muse for poets, artists, and musicians; driver of the climate; balm for the soul. From Babylon to the Yucatán, Jerusalem to China, Rome to the American Southwest, humans have tried to explain the Sun on their own terms, to give it life and spirit in recognition of how it guides and controls their lives.

In many cultures, the Sun has been a deity and often the creator. Ra was king of Egyptian gods, creator of the universe, and a charioteer who blazed across the sky to watch over the world. The ancient Greeks looked to Helios, the Romans to Apollo; both rode chariots like Ra, but they were offspring of the immortal rulers Zeus and Jupiter, respectively. Helios could see all and know all. Apollo was full of logic, reason, and music.

In Mesopotamia, the cradle of civilization, Gilgamesh struggled through an epic quest to pass through a gate—a mountain pass on the horizon where the Sun disappeared at sunset—into the everlasting Garden of the Sun. The Aztecs counted not one sun, but five; four had ruled previous eras, and Tonatiuh was the latest ruler of the heavens.

And though Jews and Christians do not equate the Sun with God, they put it at the heart of the Genesis story. Yahweh separated light from darkness in the first act of creation; by the fourth day, he created the sphere of the Sun to separate day from night.

Sun worship stems from a fundamental truth: Life as we know it would not exist without our nearest star. The Sun makes the planet habitable by warming it to temperatures at which we can thrive; that is, where water is mostly liquid. Our distance from the Sun seems to help, as evidenced by Venus—too close and too hot—and Mars—too far and too cold.

The Sun supplies the energy for the primary producers on Earth's surface: plants. Through the magic of chlorophyll and photosynthesis, plants turn sunlight into food for themselves and animals. They also become the fossil fuel of tomorrow, as most oil and gas comes from the remnants of ancient plants (sorry, dinosaurs). Humans have found creative ways to mimic plants by harnessing sunlight and putting it to work in adobe houses, solar cookers, and photovoltaic cells.

Earth's weather and climate are driven by the Sun and our circuit around it. Every square foot of Earth is bombarded by more than 130 watts of sunlight and heat, which evaporates water to make clouds and precipitation. It warms the land and the oceans to varying degrees, driving the movement of air and water in wind and currents. Sunlight and its reflection warm the gas and water vapor in the atmosphere, trapping heat in the natural greenhouse effect.

And in spite of what you've heard, the change of seasons has nothing to do with our distance from the Sun. (In fact, we are farthest from the Sun in early July and closest in January, and the difference in distance is not very large, anyway). The reason for the seasons is the tilt of the Earth on its axis—a sort of invisible line pointing through the planet from North Pole to South. As Earth spins, this axis is angled 23.5 degrees compared to the Sun. So depending on the time of year and where Earth is in its yearly circuit around the Sun, we are either tilted toward the Sun or away from it. If you live in the north-

ern hemisphere, your half of the planet is tilting toward the Sun in summer, leaning away in winter, and somewhere in between in spring and fall. The pattern is flipped if you live in the southern hemisphere.

The amount of sunlight falling directly on any parcel of Earth changes throughout the year. In summertime, sunlight beats directly on one hemisphere and the beams fall more obliquely over the other, warming different parts of the planet to different degrees. Nothing much ever changes if you live near the equator. And at the extremes of the poles, the Sun doesn't set in midsummer and it never rises in midwinter.

Plants and the planet lean toward the sun, and so do humans. Think of how many songs and poems and paintings celebrate the warmth and glow of the light. The Sun doesn't merely drive the climate; it drives our moods and outlook. Happy people have a "sunny" disposition. We "see the light" of wisdom and find ignorance and evil in the shadows. Gray winters and endless spring rains can leave us dour, longing for sunlight: "It's been a long, cold, lonely winter," sang George Harrison, but "here comes the sun . . . it's all right." Our bodies slow down, our energy sags, our outlook darkens. Science may even have an explanation: a common form of depression called Seasonal Affective Disorder grips many of us in the winter (perhaps more of us in higher latitudes). Researchers suspect it is a relic of our animal ancestry, an instinct to hibernate through winter. Our biological clocks, or circadian rhythms, are thrown off by the lack of sunlight.

Anthropologist Alison Jolly was less clinical about it. "Anyone who has lived through an English winter," she once said, "can see the point of building Stonehenge to make the Sun come back."

In the sky of morning twilight silhouettes some flowers waiting for the Sun. The red, orange, and yellow hues of sunrise and sunset occur because light is bent by the lenslike atmosphere and has to pass through as much as forty times more air to reach your eye than it does at midday. Dust, aerosols, gases, and other atmospheric scatter most of the other colors of light.

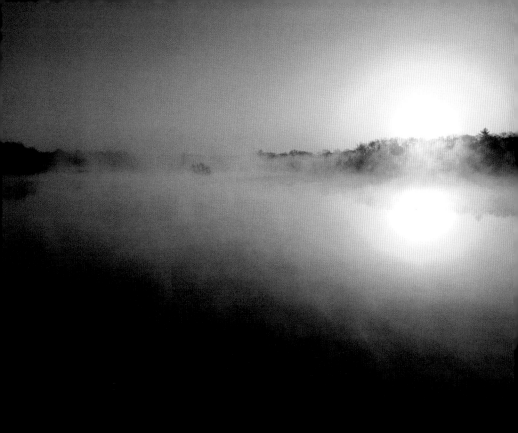

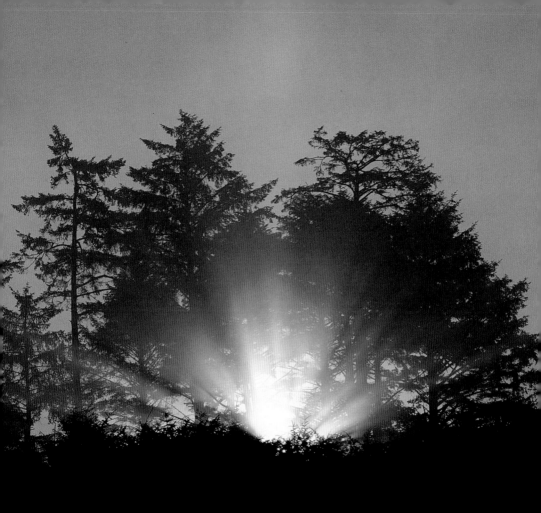

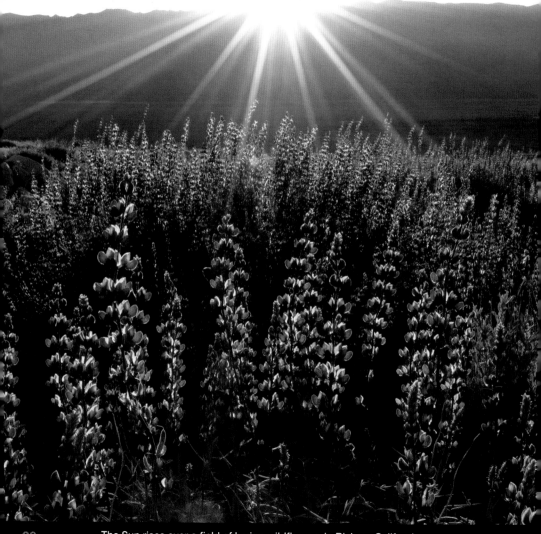

The Sun rises over a field of lupine wildflowers in Bishop, California.

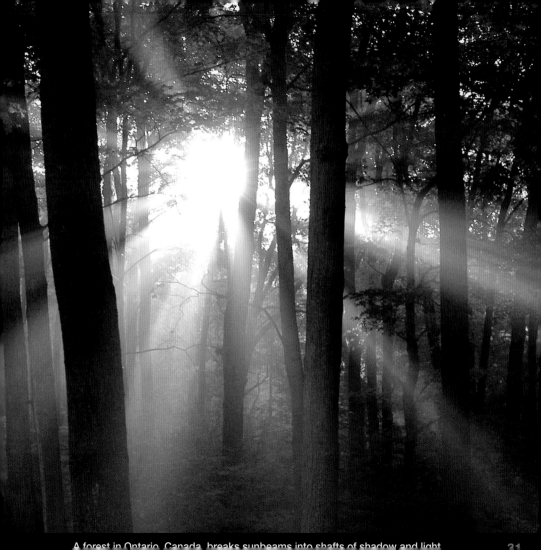

A forest in Ontario, Canada, breaks sunbeams into shafts of shadow and light.

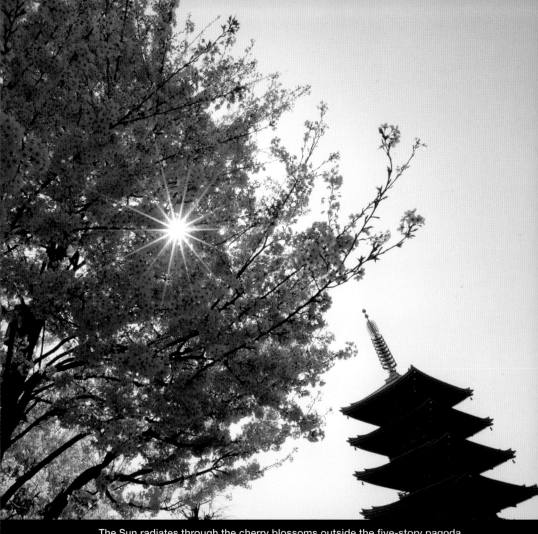

The Sun radiates through the cherry blossoms outside the five-story pagoda near the Sonsoji Temple in Tokyo.

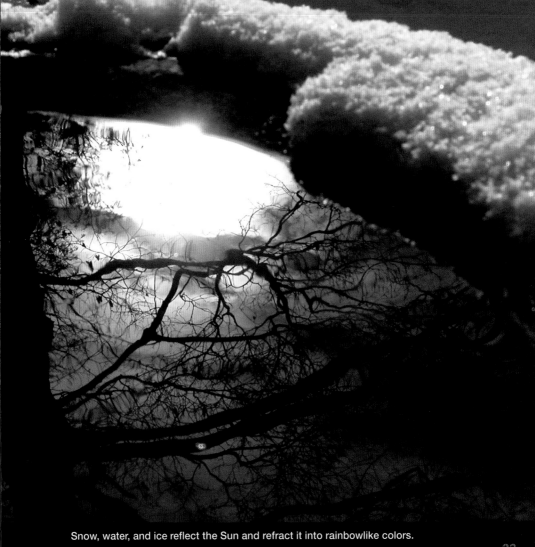

Snow, water, and ice reflect the Sun and refract it into rainbowlike colors.

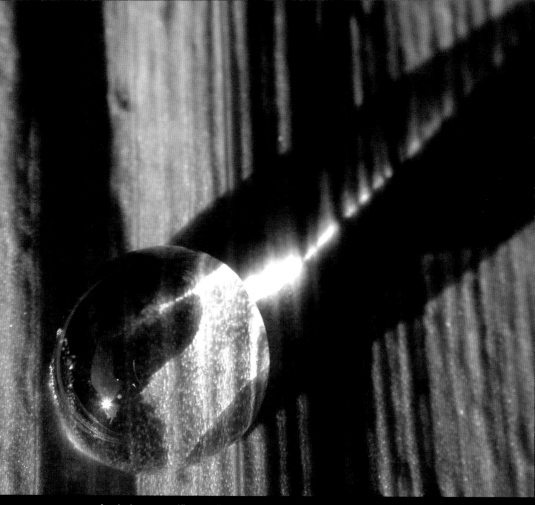

A raindrop magnifies sunlight and casts a shadow.

→ Fishermen ply the waters in late afternoon near Ko Lanta, an island off the west coast of Thailand.

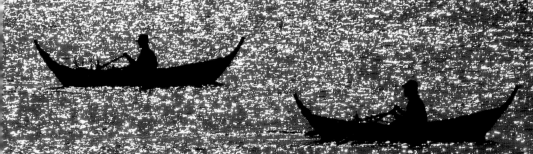

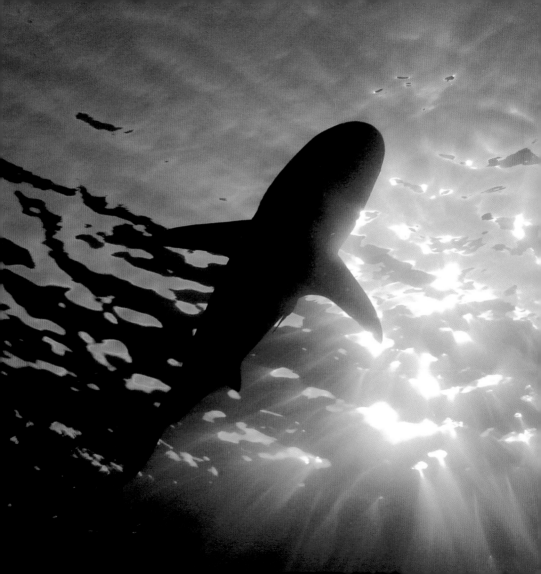

Steller sea lions bask in the sun in Kenai Fjords National Park, Alaska.

← A Caribbean reef shark cruises beneath the late afternoon sun in the waters off South Bimini in the Bahamas. Sunlight can penetrate, at most, 200 meters into the ocean (about 650 feet), with blue light (the shortest wavelength), penetrating the deepest.

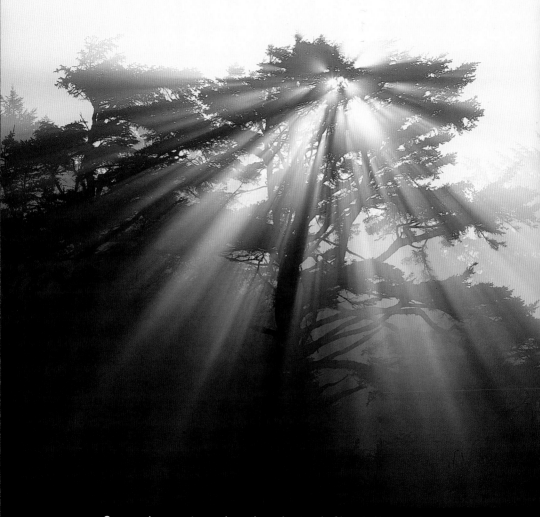

Crepuscular rays stream down through a tree in Olympic National Park in Washington.

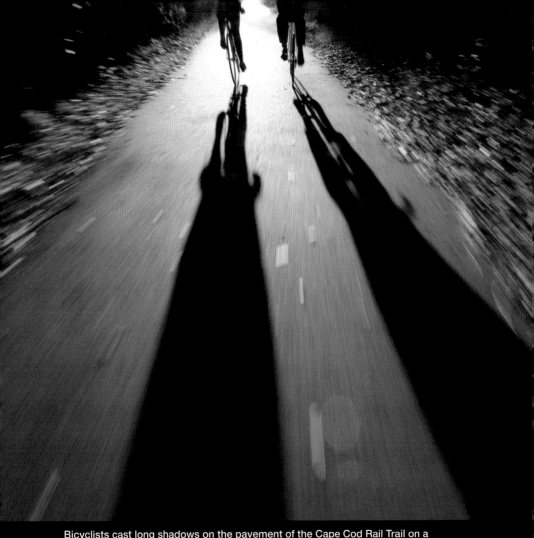
Bicyclists cast long shadows on the pavement of the Cape Cod Rail Trail on a November afternoon in Massachusetts.

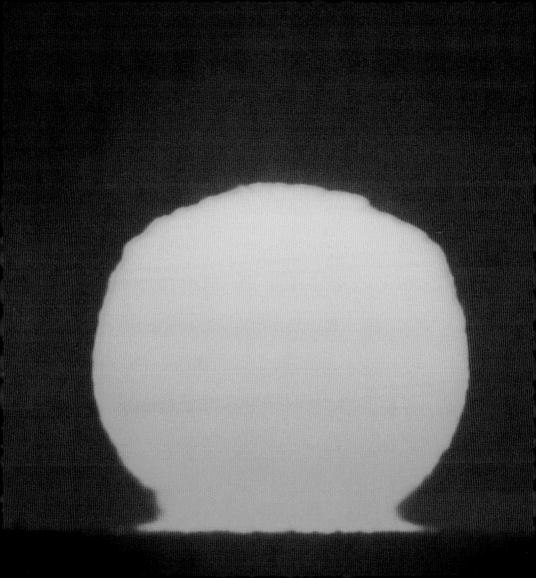

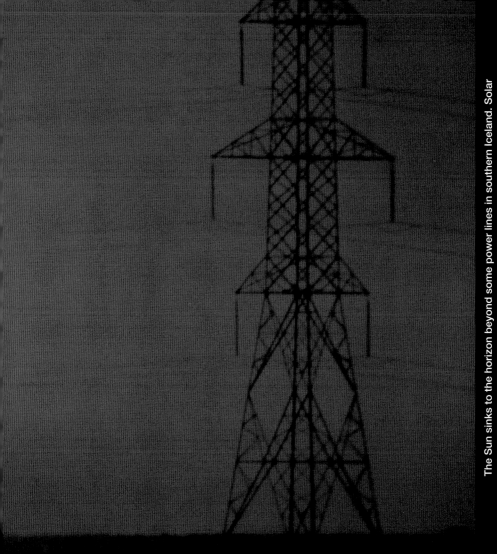

The Sun sinks to the horizon beyond some power lines in southern Iceland. Solar activity can generate magnetic storms around Earth, occasionally putting enough extra current into electrical systems to cause blackouts.

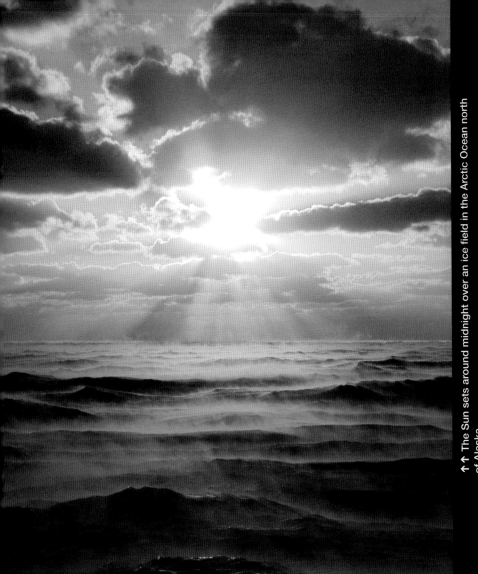

↑↑ The Sun sets around midnight over an ice field in the Arctic Ocean north of Alaska.

↑ A thick fog of "sea smoke" billows from the Atlantic Ocean as cold north winds blow over warm Gulf Stream waters off Cape Hatteras, North Carolina.

43

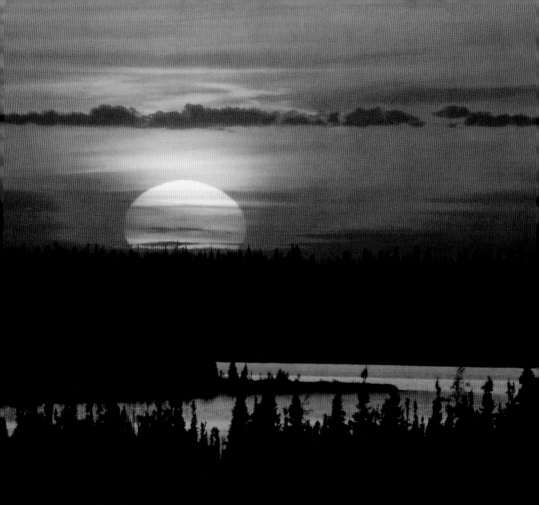

The Sun and sky turn red at sunset on James Bay in Quebec.

→ Sunrise brightens the undersides of the clouds, as viewed by climbers looking down from Mount Kilimanjaro in Tanzania.

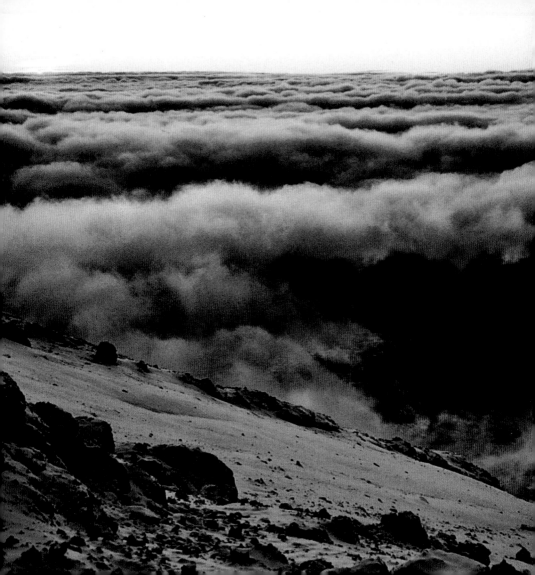

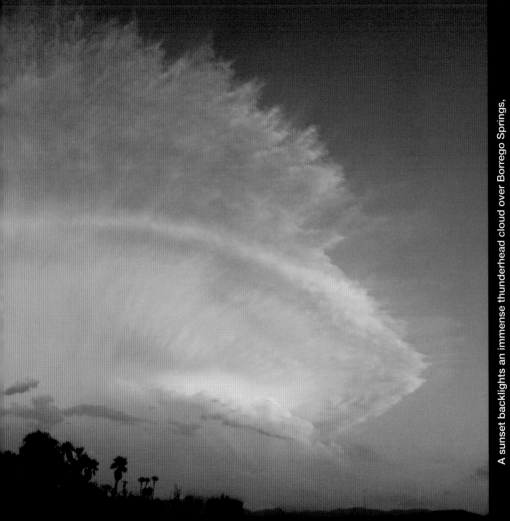

A sunset backlights an immense thunderhead cloud over Borrego Springs, California.

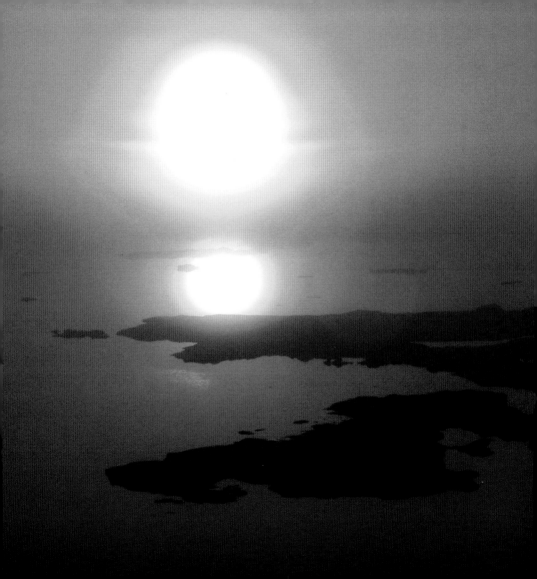

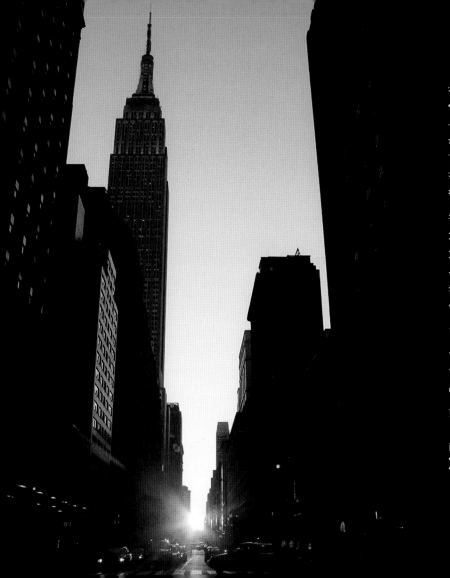

↑↑ The setting Sun is almost perfectly doubled by its reflection in the icy Arctic Ocean near Alaska.

↑ The concrete and glass canyon of 34th Street in Manhattan is flooded with the light of sunset. The city's streets are aligned such that the Sun sets on the centerline of the road every May 28 and July 12.

49

Tricks of Light

My heart leaps up when I behold
A rainbow in the sky . . .

William Wordsworth

An unusual double rainbow hovers over Galway, Ireland. One rainbow is caused by light refracting once through the droplets; the second bow is caused by light bouncing around inside the droplets and exiting at a different angle.

TO THE ASTRONOMER looking out into the void for a view of other stars and planets, Earth's atmosphere is a frustratingly murky river of water, dust, and gas. But when it comes to watching our nearest star, the atmosphere is a fine palette, filter, and prism for teasing out the colors and tricks of sunlight.

About 3,100 cubic miles of water—mostly water vapor—is swirling in the atmosphere at any given moment. If it all fell at once, the entire Earth would be covered with an inch of water. But the amount of water above any given location can range from almost nothing over deserts to nearly four percent of the atmosphere over oceans. The result is a vast array of optical spectacles; some you see every day, while others may be visible once in a lifetime.

Though the Sun appears yellow in most works of art, it actually shines with white light, a mixture of all the colors and electromagnetic waves of the spectrum. The Sun's radiation is made up of visible light, radio waves, microwaves, infrared and ultraviolet radiation, X-rays, and gamma rays. They are not in equal proportion, however. Visible light accounts for 43 percent of the energy reaching Earth from the Sun (and it happens to be brightest in the yellow-green portion); another 49 percent is near infrared light; ultraviolet composes seven percent, and the remainder includes all the other forms of light.

So if sunlight encompasses all the colors of the rainbow, and space is black and dark, why is the sky blue? Earth's atmosphere is full of gas, mostly nitrogen and oxygen molecules. When sunlight shines on the planet, its photons collide with those gases, which scatter the light. Longer wavelengths of light pass through the atmosphere more readily than shorter ones, so blue light is scattered ten times more than red (at the other end of the visible spectrum). The frequency of blue light is also closer to the "resonant" frequency of

the atoms in the air. Essentially, the atmosphere bounces and scatters the blue light across the sky while letting most of the other colors pass through to our eyes.

This rule goes out the window at sunrise and sunset. When you see the Sun on the horizon, its light is passing through forty times more atmosphere (vertically and horizontally) to get to your eyes than when the sun is directly overhead. That means there is more gas and water vapor to scatter the blue out of the light. The red and orange hues of early and late day are all that's left of the white light after it has passed through our gas-filled skies.

The geometry of our spherical Earth and the turbulent rush of heat, wind, and weather systems across the horizon can lead to distortions and mirages. The layering of warm air over cold, and vice versa, can cause the Sun to lose its circular shape; the atmosphere acts as a lens, shrinking or magnifying or flattening slices of the Sun as it approaches the horizon (pages 68–69). Most of us have seen a similar mirage effect on hot summer days when we spy heat rising off the pavement or sand.

Other times, the curvature of the Earth bends and twists light around its rim. The most spectacular and elusive of these effects is the mythic "green flash." Just as the Sun appears or disappears over a low and distant horizon, green light glimmers from its edge for a few seconds (page 70). The atmosphere acts like a prism, showing us the green in the Sun's "white light" after all the red and yellow have passed below the horizon.

Water and its collection in clouds sets up the most common and uncommon tricks of light. Everyone knows the rainbow, where large raindrops act like prisms, refracting light in the sky opposite from the Sun. But did you ever notice that the lower the Sun is on the horizon, the higher the top of the bows?

Or that red is always on the outermost edge of the bow and blue and violet are always on the innermost edge?

Iridescent clouds—named for Iris, the Greek deity of rainbows and messenger to the gods—have a similar origin. When clouds are forming or dispersing, water droplets in the thinner patches can bend light and make tie-dye in the sky (page 60). Unlike rainbows, which stand opposite the Sun, iridescence tends to occur in the same quarter of the sky.

Ropes of Maui, Buddha's fingers, Sun drawing water—all are colloquial names for glorious beams of light that stream down through fluffy, everyday clouds (page 71); the scientific name is crepuscular rays. The clouds block much of the Sun's light, but columns of sunlit air can peek through the gaps. When you see these rays, you are effectively looking at columns of light and columns of shadow adjacent to each other.

Nacreous clouds, sometimes called "mother-of-pearl clouds," are rare forms of iridescent clouds colored by the bending of light through ice crystals (page 74). They occur mostly at high latitudes—near the poles—and form higher in the atmosphere. Nacreous clouds appear to undulate like waves, a sign of the turbulence in the stratosphere. One of the newest scientific interests is the noctilucent cloud (pages 72–73), which forms at high latitudes and extremely high altitudes, and actually shines after the Sun goes down.

The bending and mirroring of light through different-sized ice crystals leads to a variety of geometric shapes. Pairs of sundogs form 22 degrees off the Sun on the horizon (pages 55 and 64). Sun pillars stretch out of the top or bottom of our star as it approaches the horizon (pages 66–67). Tangent arcs and haloes form ghostly circles around the Sun (pages 63–65).

Even the smallest water droplets in mists and fogs can distort sunlight.

Fogbows form when minuscule drops of water scatter light opposite the Sun (page 61). The Sun can even go down in a blaze of "glories." At sunrise and sunset, mists and low-hanging clouds in the mountains can reflect light back toward the Sun and your eyes (page 62).

Sundogs, also known as parhelia or mock suns, are halos that form to either side of the sun (horizontally) when sunlight passes through the faces of ice crystals suspended in the atmosphere.

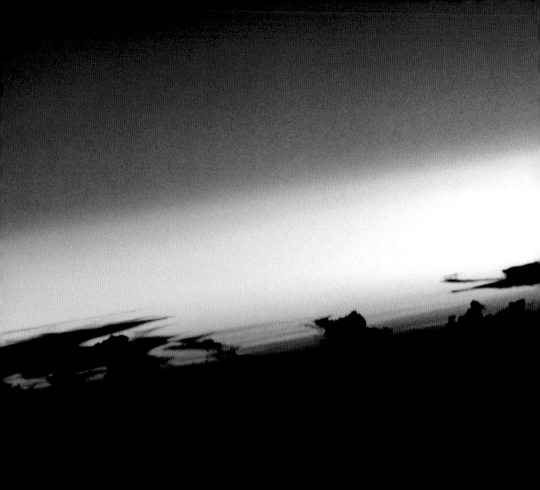

Sunrise glowing along Earth's horizon highlights the edge of space. This image was caught by an STS-68 crew member on October 11, 1994.

57

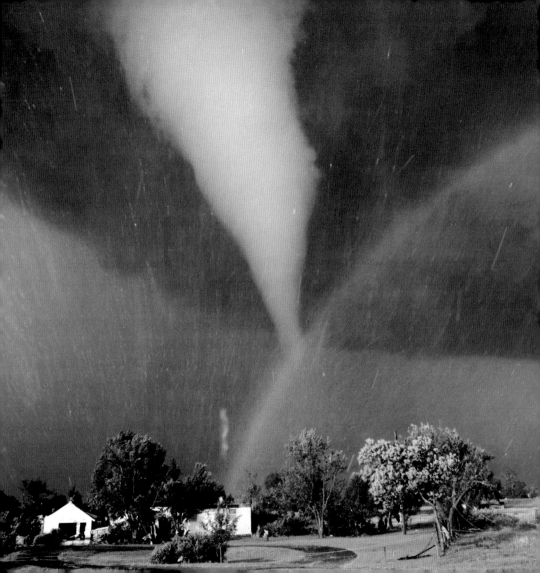

↑↑ A tornado that has not yet touched the ground in Kansas instead seems to be attached to a rainbow. The streaks in the image are caused by hail being swept into view by the high winds.

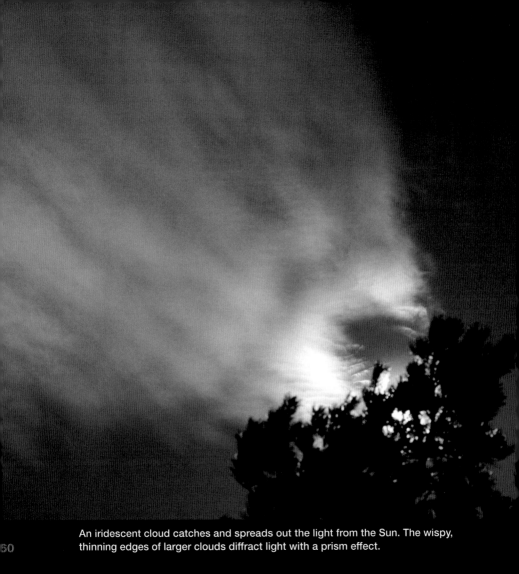

An iridescent cloud catches and spreads out the light from the Sun. The wispy, thinning edges of larger clouds diffract light with a prism effect.

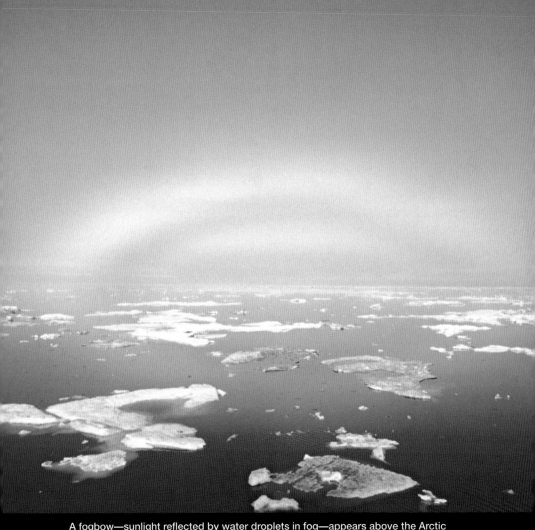

A fogbow—sunlight reflected by water droplets in fog—appears above the Arctic Ocean. Like rainbows, they form on the opposite side of the sky from the Sun.

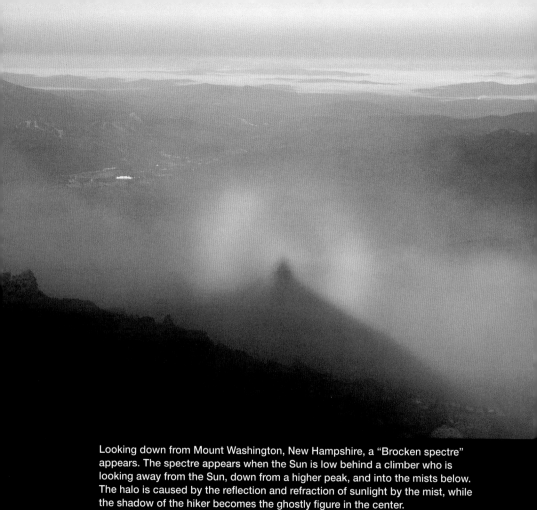

Looking down from Mount Washington, New Hampshire, a "Brocken spectre" appears. The spectre appears when the Sun is low behind a climber who is looking away from the Sun, down from a higher peak, and into the mists below. The halo is caused by the reflection and refraction of sunlight by the mist, while the shadow of the hiker becomes the ghostly figure in the center.

→ A halo arcs at 22 degrees around the Sun as it is partially hidden by a cliff. Tiny ice crystals in the atmosphere bend the light to form the ring.

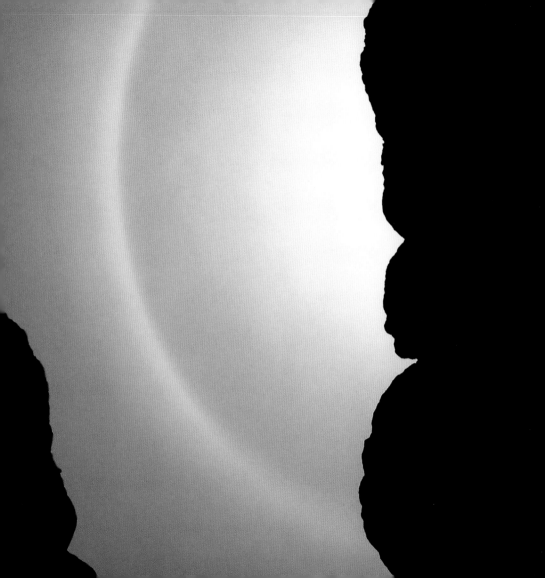

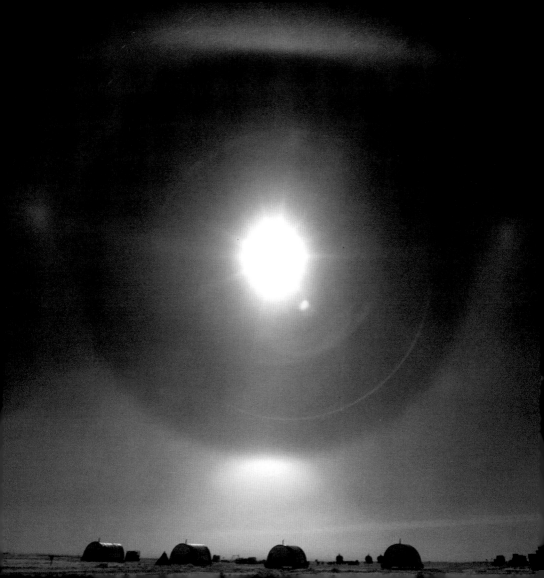

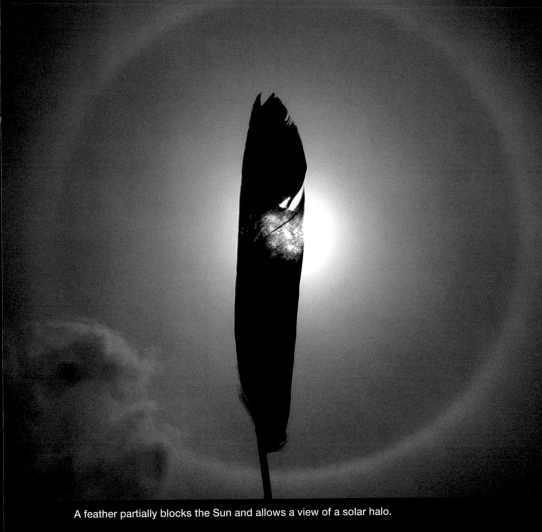

A feather partially blocks the Sun and allows a view of a solar halo.

← Sundogs and parhelia arcs appear above some research huts in Antarctica.

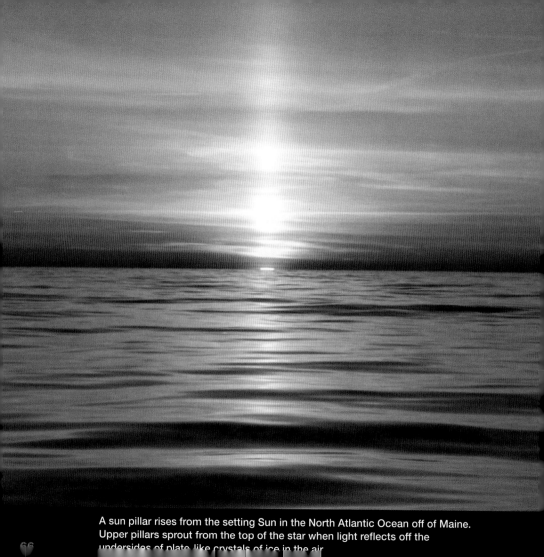

A sun pillar rises from the setting Sun in the North Atlantic Ocean off of Maine. Upper pillars sprout from the top of the star when light reflects off the undersides of plate-like crystals of ice in the air.

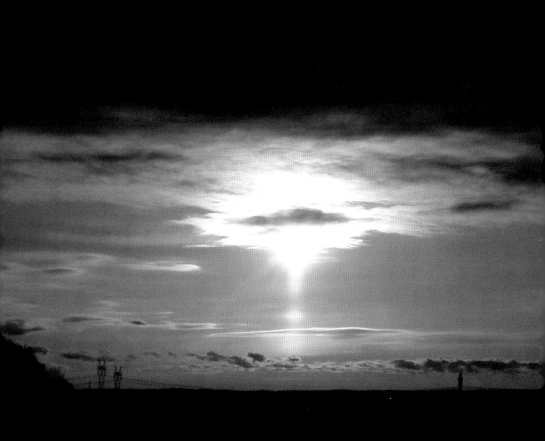

A sun pillar stretches downward from the Sun as it sets in Ontario, Canada. Lower pillars form when light is reflected upwards from the topsides of ice crystals in the air.

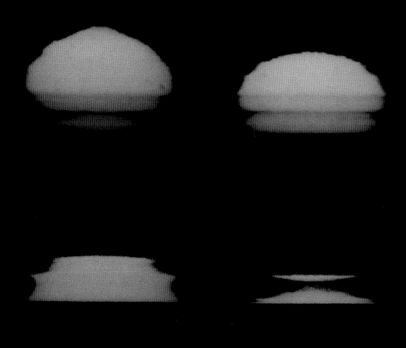

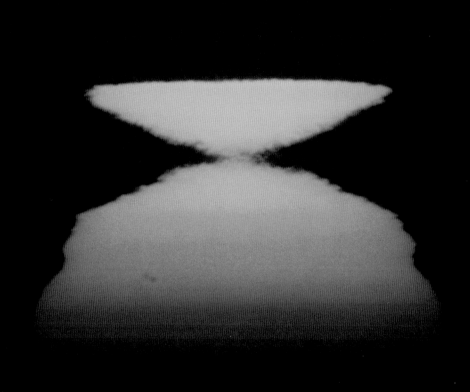

← ↑ Sunlight is sometimes distorted and reflected—literally bending around the rim of the Earth—as it passes through layers of the atmosphere close to the horizon. Differences in the temperature of air masses near the surface of Earth (particularly over water) can cause the Sun's image to become inverted.

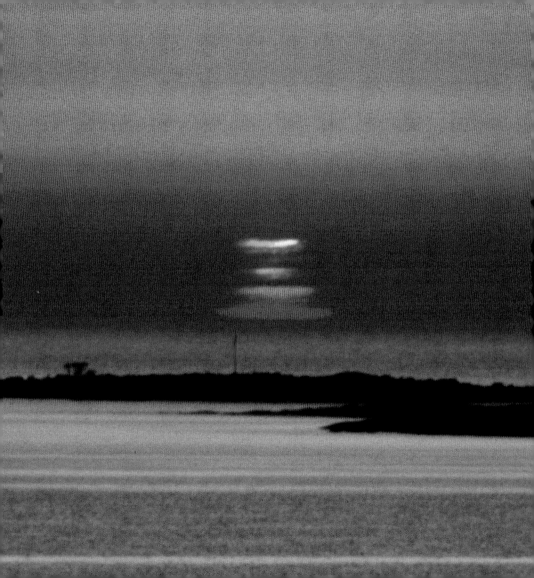

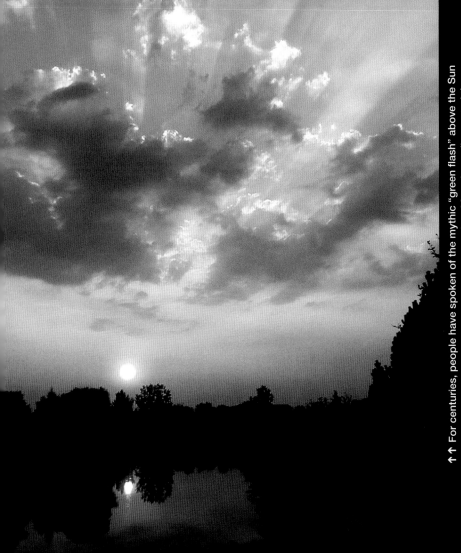

↑↑ For centuries, people have spoken of the mythic "green flash" above the Sun as it peeks over the horizon at its rising and setting. Many have discounted the effect as wishful thinking; photographs show the myth to be reality.

↑ Crepuscular rays, shown here at sunset in Ontario, Canada, form as clouds create columns of shadow that interrupt and surround columns of light.

71

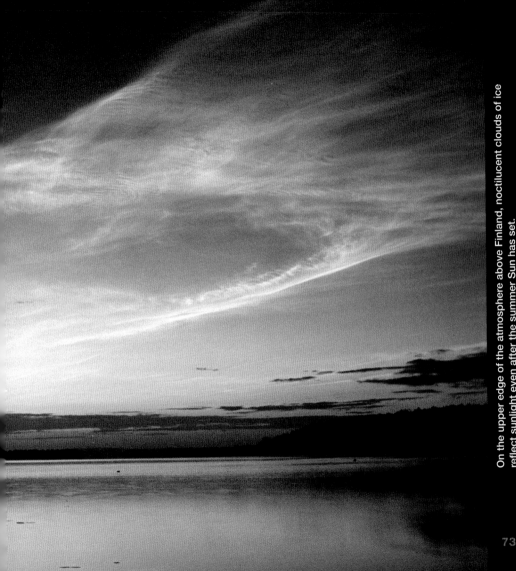

On the upper edge of the atmosphere above Finland, noctilucent clouds of ice reflect sunlight even after the summer Sun has set.

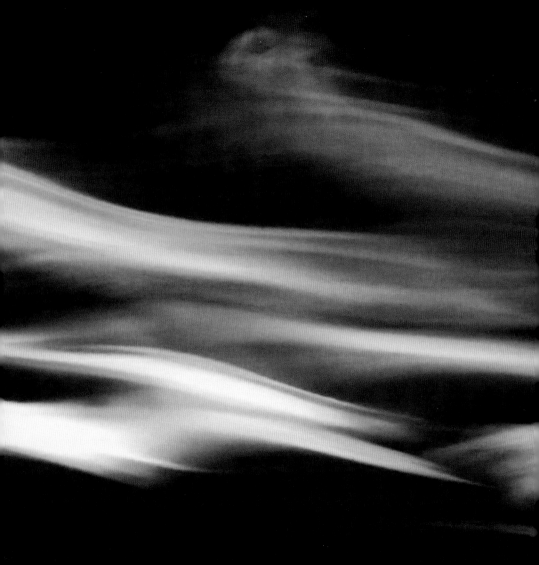

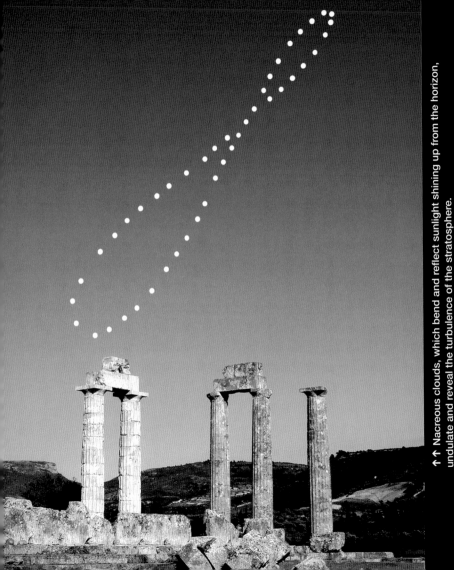

↑↑ Nacreous clouds, which bend and reflect sunlight shining up from the horizon, undulate and reveal the turbulence of the stratosphere.

↑ The analemma is a figure-eight pattern that you get when you mark the position of the Sun at the same time each day throughout the year as Earth's tilt changes relative to the Sun. This image is composed of 44 exposures recorded from Nemea, Greece, on a single piece of film.

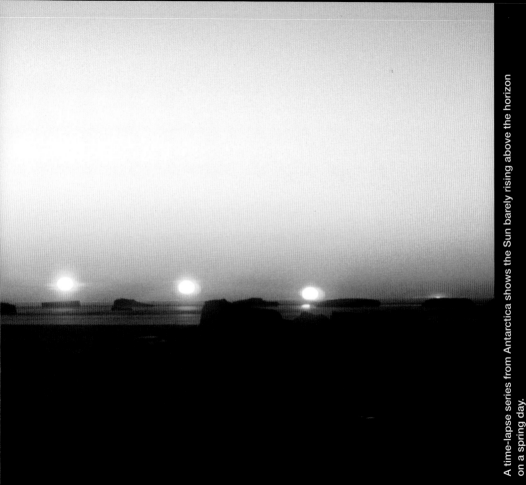

A time-lapse series from Antarctica shows the Sun barely rising above the horizon on a spring day.

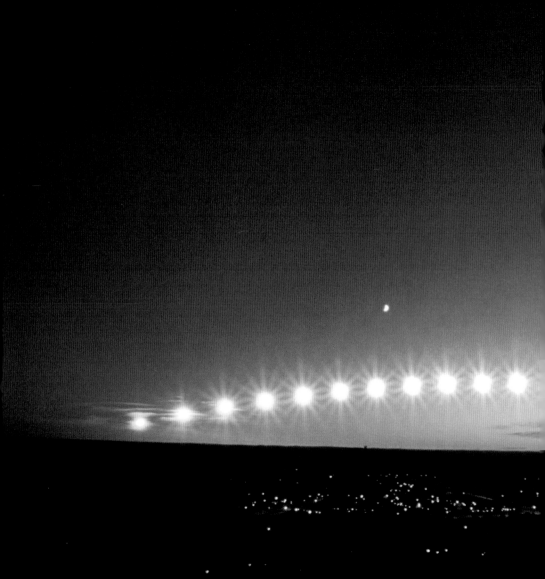

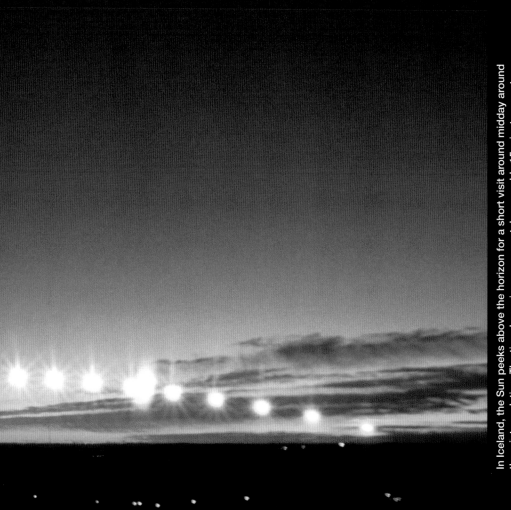

In Iceland, the Sun peeks above the horizon for a short visit around midday around the winter solstice. The time-lapse images were taken roughly 15 minutes apart.

I'll Follow the Sun

I count only the sunny hours.

Famous epigram on sundials

The pyramid of El Castillo dominates the landscape at Chichén Itzá on Mexico's Yucatán Peninsula. The Mayans built "The Castle" around AD 800 as a temple to the feathered serpent god Kukulcán. It was laid out with specific solar orientation.

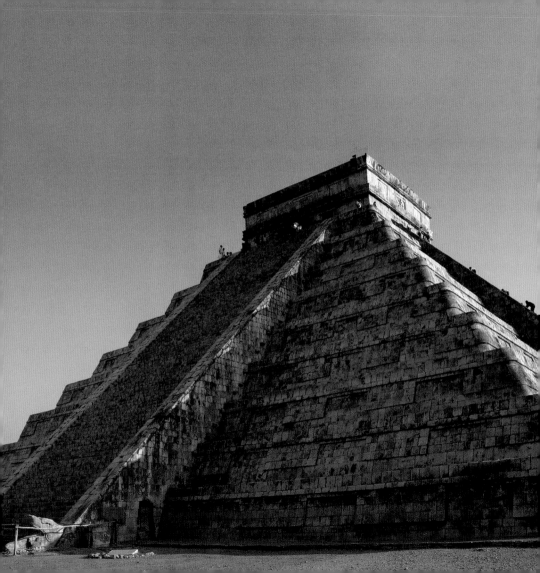

NEOLITHIC PEOPLE BUILT STONEHENGE to trace the seasons. Ancient Chinese astronomers blinded themselves trying to get a better look at the Sun's spots. Galileo pointed his telescope at it and was kicked out of the Catholic Church for what he saw. Louis Fizeau and Léon Foucault took the first photograph of it. And the European Space Agency and NASA built SOHO to watch it 24 hours a day. Our understanding of the Sun has evolved with each new and clearer view.

To the naked eye, the Sun is "old reliable," barely changing from sunrise to sunset, from year to year. So why do billions of people still gather to worship the Sun on Machu Picchu or to glimpse it at eclipse festivals? Why does everyone spend so much time looking at our nearest star?

Aside from simple curiosity, there are several reasons to observe the Sun. It is the master timekeeper; hence, the sundial, which tells the hour by casting shadows based on the Sun's path across the sky.

The more observant among us also realize that the position of the Sun changes not just within a day, but also progressively from day to day across the year. The changing height and angle of the Sun allows us to keep track of the seasons and to know when to plant our crops. The "Sun room" at Hovenweep Castle (page 86)—a Pueblo monument on the Utah-Colorado border—likely was used to mark the equinoxes and solstices for a great agrarian civilization that thrived in the mesas and canyons from AD 500 to 1300. Portals in the castle walls projected shafts of sunlight onto drawings inside the structure, tracing the march of the seasons.

Mystics watch the Sun because they think it tells something about how the celestial clockwork might foretell events on Earth. Cosmic occurrences such as eclipses, auroras, comets, and sunspots have been read as clues of divine

will or damnation, signals from the heavens that could alter events on Earth. Wars and the fates of great leaders have been intertwined with the activities of the Sun.

Sometimes the mystic and the practical are intertwined. At the Mayan pyramid of Kulkulcán, the play of sunlight on the edge of the structure casts an undulating shadow on the side of a staircase, revealing the feathered serpent god who descends as the day of the summer solstice progresses (page 81). The northwest and southwest corners of the pyramid point toward the horizon where the Sun rises at the summer solstice and sets at the winter solstice. Similarly, the Temple of the Sun at Machu Picchu receives a shaft of light through its east-facing window on the summer solstice, while the Sun balances and rests on the "heel stone" at Stonehenge on that same day.

One of the most ancient and enduring ways to observe the Sun is through an eclipse or transit. The word *eclipse* comes from a Greek word meaning "to leave," and for many cultures a solar eclipse was perceived as the Sun abandoning Earth. Solar eclipses happen when the new Moon passes directly between the Sun and Earth, leaving a portion of the planet in the Moon's shadow. This event occurs roughly once every 18 months. Conversely, lunar eclipses occur (at least twice each year) when Earth's long shadow crosses the path of the full Moon. Planetary transits occur a few times a century when the geometry and motion of the solar system places Venus or Mercury directly between the Sun and Earth; the event looks like a spot moving across the face of the Sun over a period of several hours.

The earliest record of a solar eclipse comes from ancient China, around 2134 BC. The ancient document *Shu Ching* records that "the Sun and Moon did not meet harmoniously." A Chinese folk legend explained that an eclipse

was actually the work of an invisible dragon devouring the Sun; such events prompted people to make loud noise during eclipses to frighten the dragon away. According to another story, the royal astrologers Hsi and Ho once failed to properly warn the people of an impending eclipse. They were executed.

Eclipses have had an effect on civilization, as superstitious beliefs have precipitated real-life events. Those who could predict eclipses had a great deal of power. The ancient Babylonians were the first to work out the Saros cycles, the mathematical formula that tells when eclipses will occur by calculating the position of the Moon and Earth. The medicine wheels of the North American prairies—mystical calendars of the seasons—also may have included mechanisms for predicting when Earth and Moon would cast their shadows.

Perhaps the most famous eclipse of ancient times occurred in 585 BC. The Greek philosopher Thales predicted a solar eclipse, which occured in the midst of a battle between the nations of Lydia and Media. Seeing the day turned into night, the startled warriors stopped fighting and agreed to a peace treaty.

Millions of pilgrims and tourists still trek to the "path of totality"—the shadowed swath of Earth where the Moon blots out the Sun. Grand celebrations and cultural events are planned around these days. Even scientists celebrate total eclipses, though not just for their mythic value. An eclipse is the only way to see the atmosphere of the Sun without fancy instruments. When compared with the density of the gas and the intensity of the light on the Sun's visible surface, the hot, ionized gas of the upper atmosphere, or corona, is a million times dimmer.

Galileo was one of the first astronomers to point his telescope at the Sun. Christopher Scheiner, Galileo, and others eventually learned to project the Sun's image onto paper and other backgrounds for safer viewing—a trick that allowed them to see and record spots on the Sun. Photographers and optical

inventors eventually took over, creating lenses and filters to sharpen the view and tease out narrow wavelengths of sunlight, such as hydrogen alpha or calcium lines. In 1930, French astronomer Bernard-Ferdinand Lyot figured out how to create eclipses every day, by developing the coronagraph—which uses a disk to block the visible surface of the Sun—to study the corona.

Scientists and amateur astronomers still know there is much to see in that orange-yellow disk and still more to learn, which is why they have designed telescopes and satellites that have ushered in a golden age of Sun studies. Over the past thirty years—from Skylab to SOHO—Sun watchers have gained an unprecedented view of our nearest star and its impact on Earth.

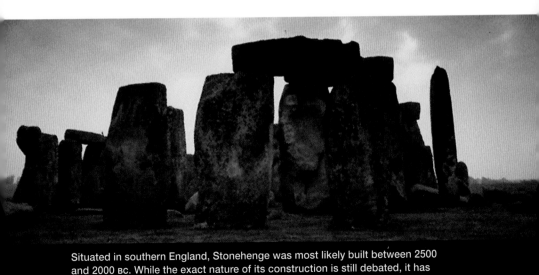

Situated in southern England, Stonehenge was most likely built between 2500 and 2000 BC. While the exact nature of its construction is still debated, it has been determined to have a number of alignments that suggest an understanding

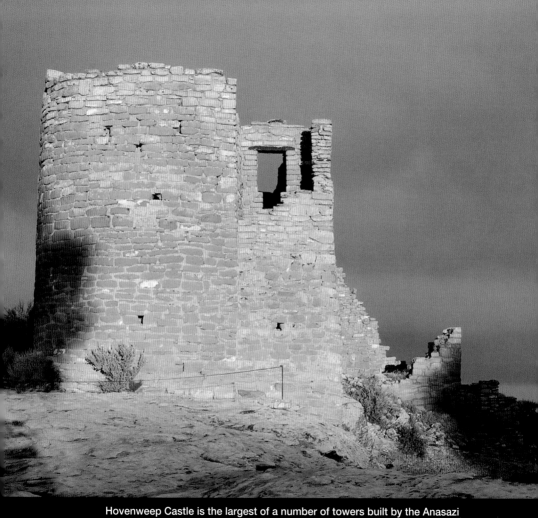

Hovenweep Castle is the largest of a number of towers built by the Anasazi around AD 1200 along the Utah-Colorado border. Researchers believe that solar observing, or at least measurement of the seasons, was one of its purposes.

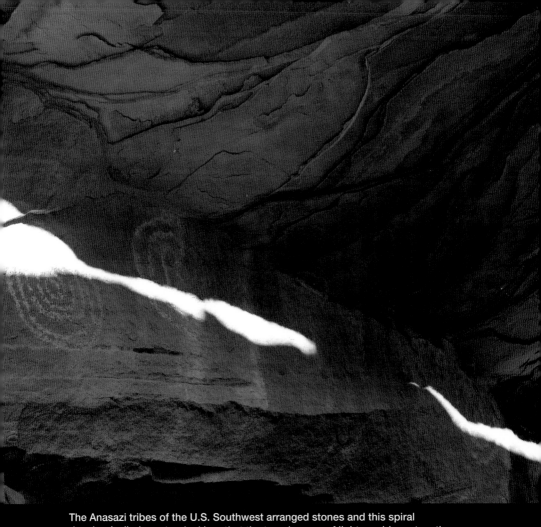

The Anasazi tribes of the U.S. Southwest arranged stones and this spiral drawing (called a petraglyph) so that the two daggers of light would meet on the

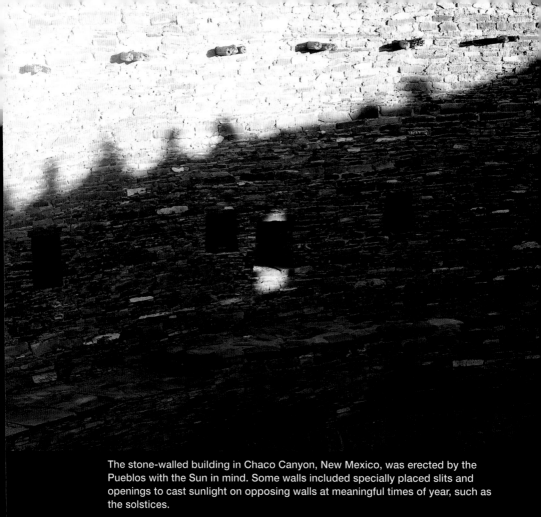

The stone-walled building in Chaco Canyon, New Mexico, was erected by the Pueblos with the Sun in mind. Some walls included specially placed slits and openings to cast sunlight on opposing walls at meaningful times of year, such as the solstices.

→ Community leaders built this modern Sun circle in Tucson, Arizona, to capture

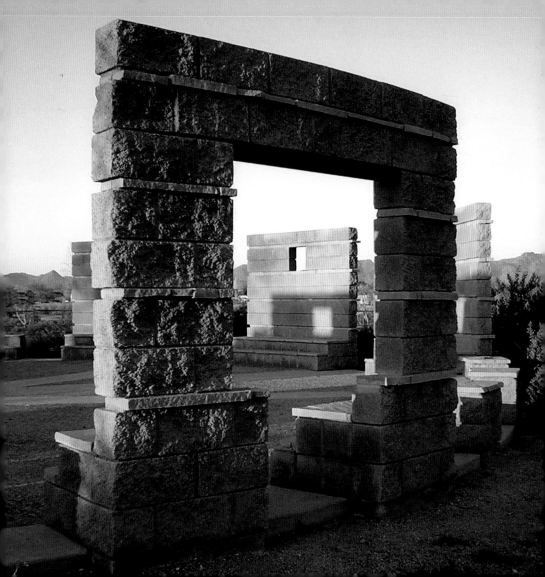

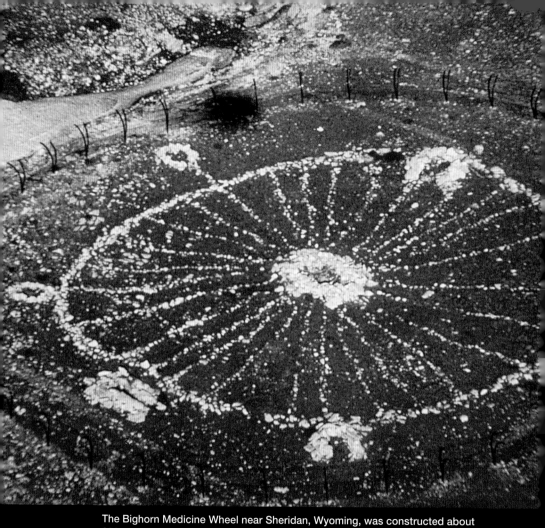

The Bighorn Medicine Wheel near Sheridan, Wyoming, was constructed about 800 years ago by the Plains Indians. The stones of the site appear to be arranged to plot the location of the rising and setting Sun on the solstices.

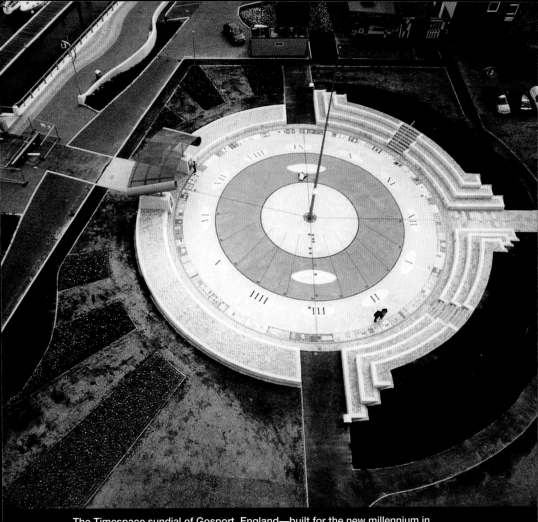

The Timespace sundial of Gosport, England—built for the new millennium in 2000—is now the largest in the United Kingdom, measuring slightly over 131 feet across.

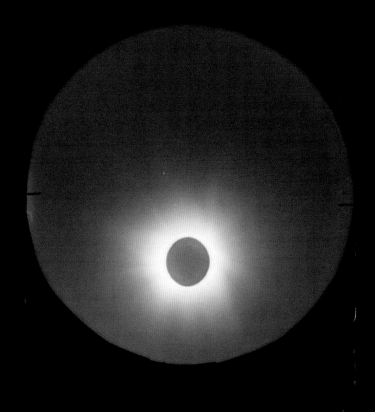

This early photograph of an eclipse was captured on a glass plate on April 16, 1893. The Sun is 400 times larger than the Moon, which happens to be 400 times closer to Earth.

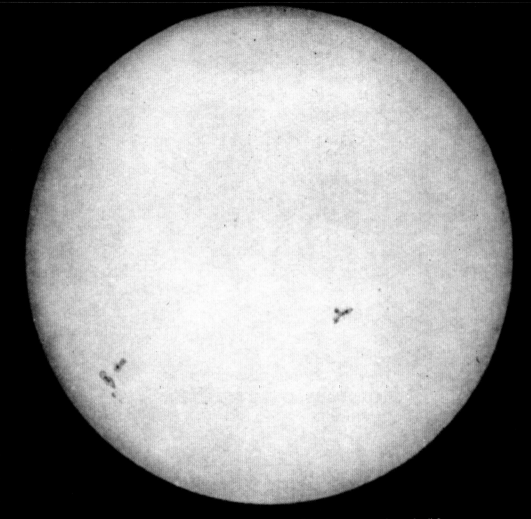

This first photograph, actually a daguerreotype, of the Sun was made on April 2, 1845, by French physicists Louis Fizeau and Léon Foucault. Note the sunspots.

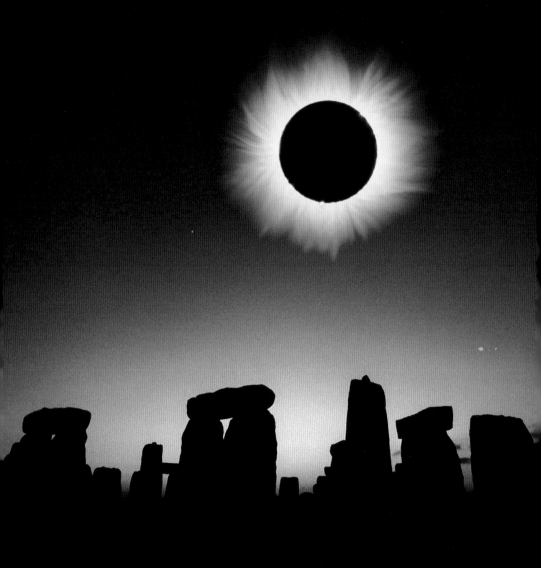

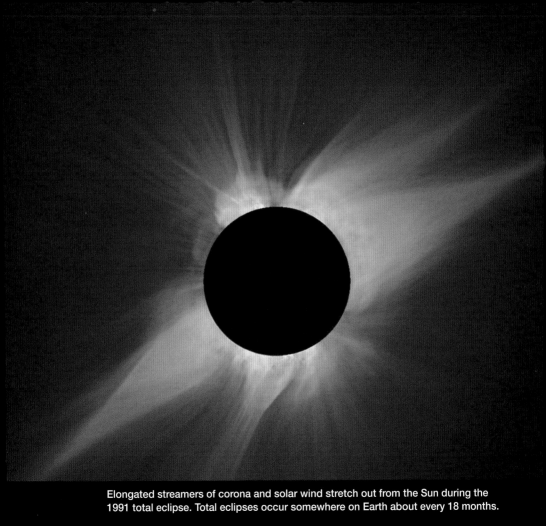

Elongated streamers of corona and solar wind stretch out from the Sun during the 1991 total eclipse. Total eclipses occur somewhere on Earth about every 18 months.

← This composite image hints at the relationship between Stonehenge and the Sun. More than 1,500 stone circles exist in Britain alone.

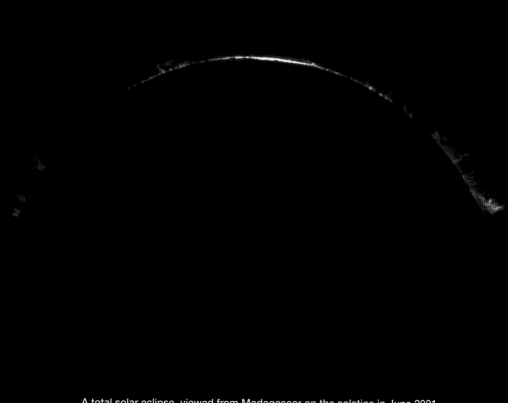

A total solar eclipse, viewed from Madagascar on the solstice in June 2001, shows prominences rising above the limb of the Sun.

→ The bright lights emerging around the edge of the Sun just after the "totality," or peak, of an eclipse are known as Baily's Beads. The effect is named for British astronomer Francis Baily, who vividly described them after an annular eclipse on May 15, 1836. The bead effect occurs as light from the Sun cuts through the mountains and valleys of the lunar surface.

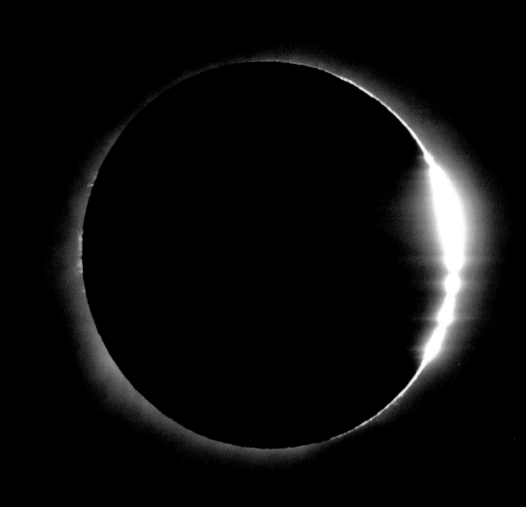

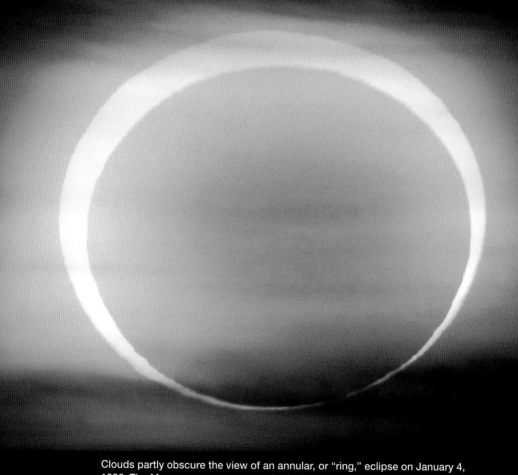

Clouds partly obscure the view of an annular, or "ring," eclipse on January 4, 1992. The Moon was near apogee—its farthest distance from Earth—while Earth was at perihelion—its closest approach to the Sun.

→ Clouds pass in front of a partial solar eclipse as the Sun sets over Hawaii in October 2004.

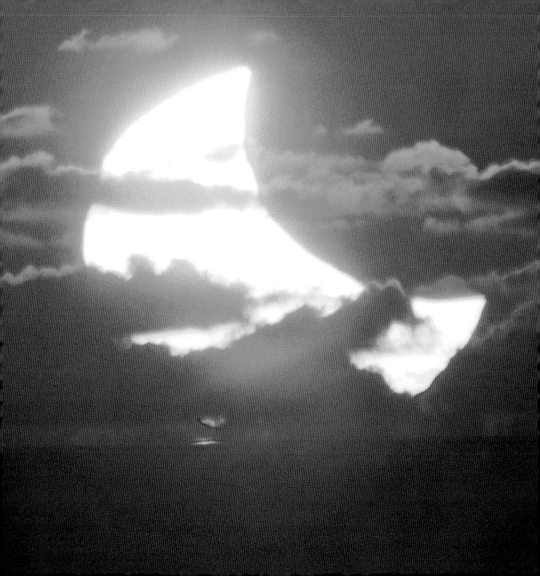

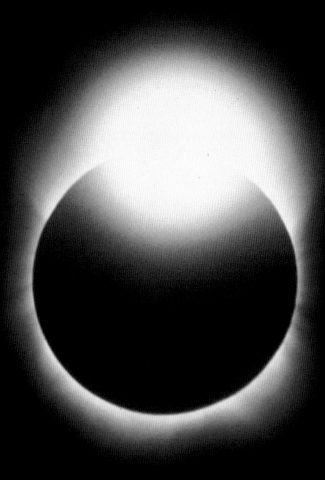

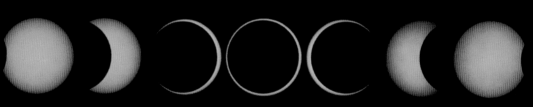

Annular eclipses, such as this one in 1994, occur when the Moon blocks most, but not all, of the Sun's light. The Moon's orbit is not a pure circle, so at times it is slightly farther away from Earth in its orbit—appearing smaller to the naked eye—and changing the geometry of the eclipse.

← The "diamond ring" effect during an eclipse, like Baily's Beads, occurs as the Sun rises over the jagged limb of the Moon.

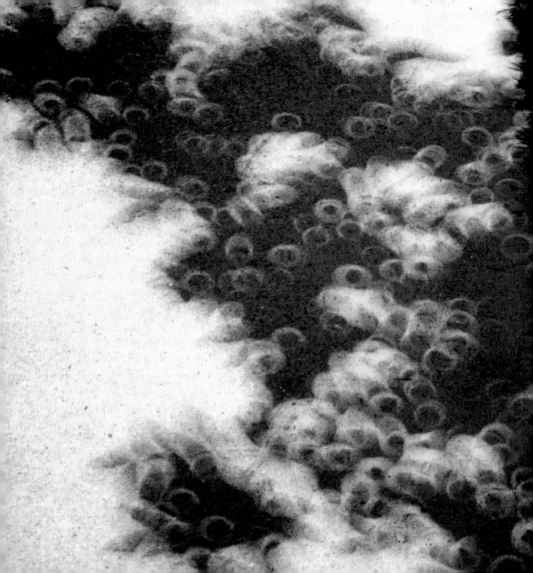

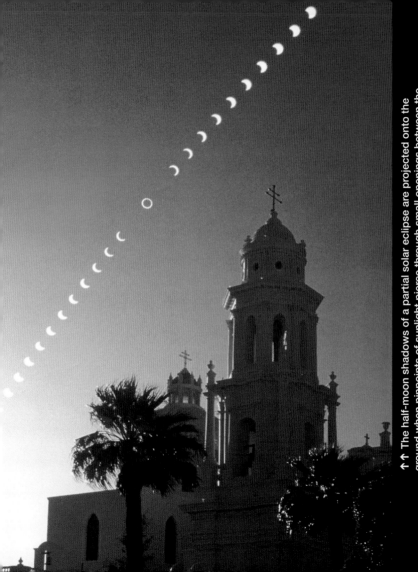

↑ ↑ The half-moon shadows of a partial solar eclipse are projected onto the ground when pinpoints of sunlight pierce through small openings between the leaves of a tree.

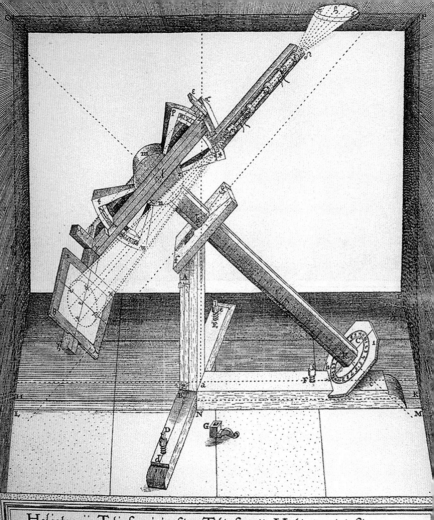

Heliotropii Telioscopici, siue Telioscopii Heliotropici figura; qua
Machina Macularum Cursus absq; ullo perpendiculo, aut laboriosa
Ecliptica ad uerticalem Circulum inclinatione aquiritur.

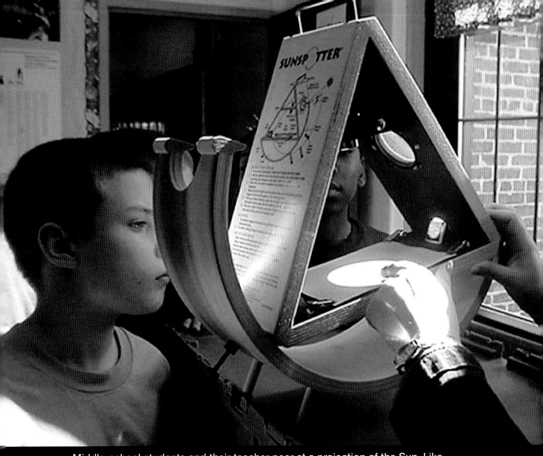

Middle-school students and their teacher peer at a projection of the Sun. Like Christopher Scheiner's helioscope, this device provides a safe way to observe sunspots.

← This 1630 sketch of a helioscope shows how German astronomer Christopher Scheiner (a contemporary of Galileo) and other early telescope users projected the light of the Sun onto paper and other surfaces so that they could observe

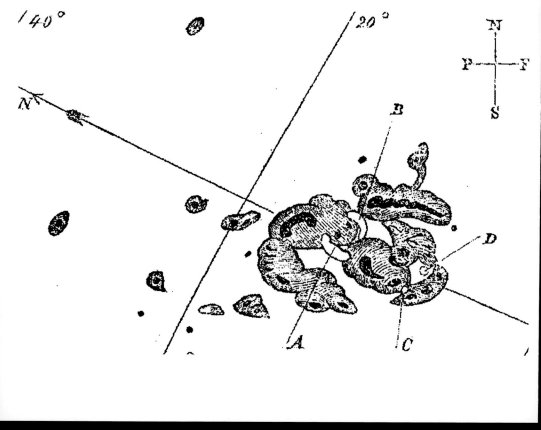

British astronomer Richard Carrington drew this sketch of the Sun on September 1, 1859, after making the first observation of a solar flare. The white bands buried amid the black and gray sunspots depict the twin bands of the white-light flare as it burst into view around the sunspots.

→ Scheiner included these drawings of sunspots in his book *Rosa Ursina*, one of the first great studies of sunspots. His method of illustrating the motion of individual spots across the face of the Sun became the standard

M.DC.XXV.

In Domo Professa Romana Societatis

Cursus Maculæ, à 18, Aprilis ad 1.ᵐ Maij; similis
aliis aliorum annorum tempore eodem.

APRILIS.				APRILIS.				MAII.			
D	H	☉	El	D	H	☉	El	D	H	☉	El
18. u.	3½	30.	20.	25. m.	9½	44.	45.	1. m.	6½	20.	10.
19. u.	5½	16.	20.	26. m.	7½	26.	0.	1. m.	8½	39.	0.
21. u.	4.	27.	30.	27. u.	4½	24.	0.	1. u.	1½	57.	10.
21. u.	4½	23.	10.	28. m.	6½	20.	0.				
22. u.	3½	31.	25.	29. m.	9½	46.	40.				
23. u.	5½	15.	30.	30. m.	7½	22.	30.				
24. u.	5½	17.	40.	30. m.	11½	46.	40.				
				30. u.	4.	30.	0.				

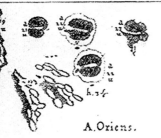

A.B. Ecliptica.

A. Oriens. B. Occidens.

B

N

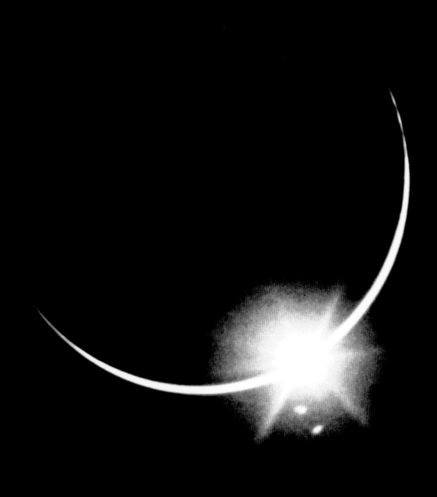

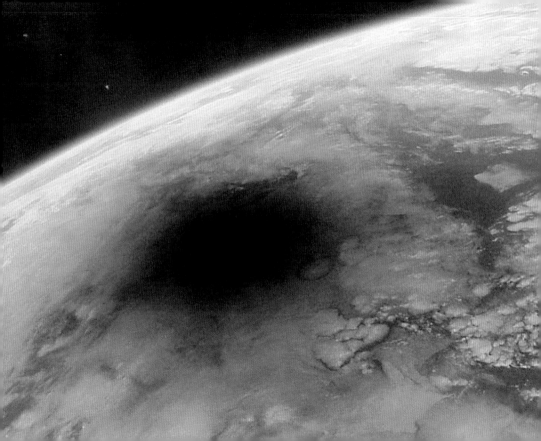

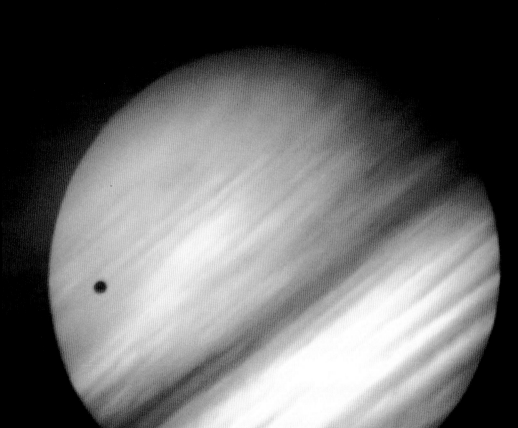

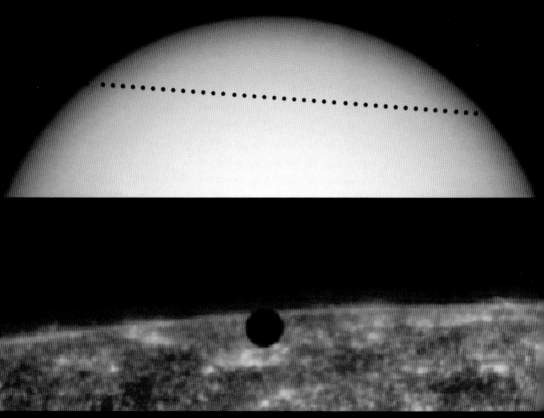

↑↑ Mercury made a transit across the Sun (from the perspective of Earth) in 1999. Only Mercury and Venus can provide these miniature eclipses since they are the only planets between Earth and the Sun.

↑ Mercury is silhouetted as it passes between the Sun and Earth in this view from the TRACE solar-observing satellite. Mercury transits occur about 13 times per century.

← The dot on the left-hand side is Venus passing in front of the Sun.

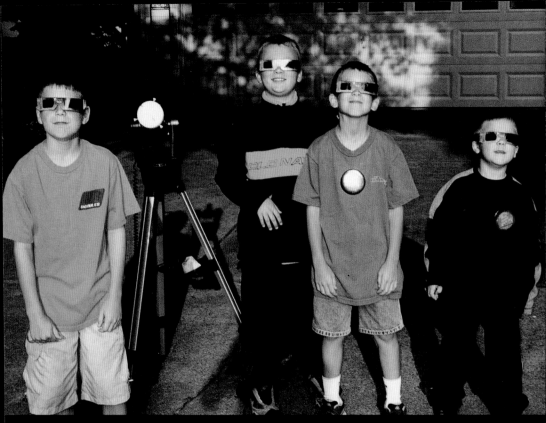

A group of children in Maryland woke up early and donned solar viewing glasses to observe the transit of Venus in June 2004. Understanding and predicting the transit of Venus was critical to astronomers' calculations of the distance of the Sun from Earth. The next transit occurs in 2012, an event that will not be repeated for another 122 years due to Venus's slightly tilted orbit relative to Earth.

→ An airplane and its vapor trail created another kind of solar transit for a photographer trying to observe the sunspots (center) on the solar disk.

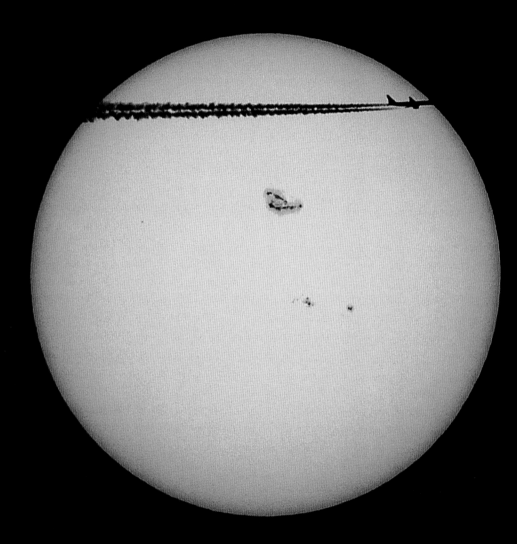

The Edge of Space

Oh! I have slipped the surly bonds of Earth
And danced the skies on laughter-silvered wings;
Sunward I've climbed, and joined the tumbling mirth
Of Sun-split clouds…

John G. Magee, "HIGH FLIGHT"

Like snowflakes, no two auroras are exactly the same. Scientists cannot explain the reasons for different shapes in the aurora.

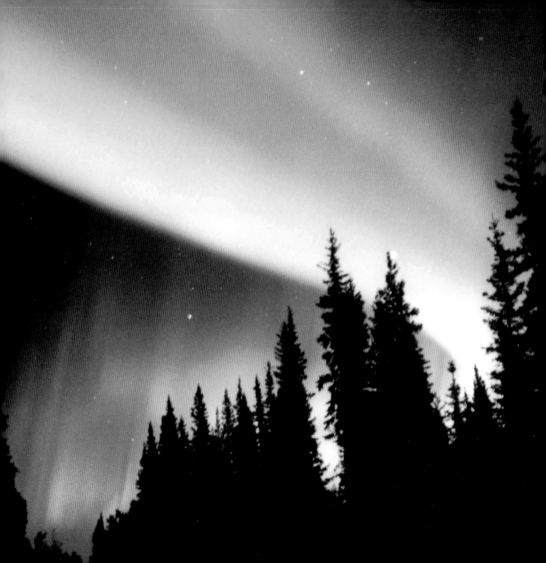

HAVE YOU EVER TRIED TO SEE the Sun at night? In a way, that's what you are doing when you look at the *aurora borealis* (northern lights) and *aurora australis* (southern lights).

Auroras are colorful, wispy curtains and arcs of light ruffling in the night sky. Named for the Roman goddess of dawn, they sometimes stretch across the horizon as flickering bands that kink, fold, and swirl. Other times, auroras streak the sky with rays or vertical shafts. Sometimes an aurora is so dim and scattered as to be mistaken for clouds or the Milky Way; sometimes it is bright enough to read by.

Humans have at times seen a lot more in the heavens than just a brilliant light show. Folklore from China and Europe describes auroras as great dragons or serpents in the skies; some researchers now speculate that the dragon faced down by Britain's patron Saint George was in fact the aurora swirling over Scotland. In Scandinavia, Iceland, and Greenland, auroras were often seen as great burning archways by which the gods traveled from heaven to Earth. Some Native American tribes pictured spirits carrying lanterns as they sought the souls of dead hunters, while the Inuit envisioned souls at play.

Sometimes, the night lights have been mistaken for fire. In AD 37, Emperor Tiberius saw a reddish light on the horizon and thought the port of Ostia was burning. He dispatched the Roman legions to aid the city, only to find nothing but an aurora in the sky. Nineteen centuries later, in 1938, the fire brigades of London were sent to extinguish a blaze near Windsor Castle that turned out to be of the auroral kind.

Some of the brightest minds in history have puzzled over the aurora. In the fourth century BC, Aristotle made one of the first truly scientific accounts, describing "glowing clouds" and a light that resembled flames of burning gas.

In the seventeenth century, René Descartes and other scientists proposed that the lights were caused by moonlight reflected or refracted by ice and water. Benjamin Franklin wrongly attributed the lights to a sort of lightning or electric discharge from clouds above the polar regions.

The scientific connection between the Sun and the aurora started to be made in 1739 when a London watchmaker, George Graham, noticed that on some days his compass needle strayed from true north for reasons he could not explain. That same year in Sweden, Anders Celsius detected the same phenomenon and noted that it seemed to occur when auroras danced in the sky. They called the phenomenon a "magnetic storm."

A century later, English astronomer Richard Carrington detected bright patches of white light emerging around some sunspots—the first reported observation of a solar flare (page 106). About 18 hours later, auroral lights appeared all over the world. Collectively, they had discovered that magnetic storms give rise to auroras.

Auroras are a sign that Sun and Earth are connected by more than sunlight. The typical aurora is caused by collisions between fast-moving electrons from space with the gas in Earth's atmosphere about 60 to 250 miles (100 to 400 kilometers) in altitude. The electrons—which come from the region of space controlled by Earth's magnetic field—transfer their energy to the oxygen and nitrogen molecules in the atmosphere, making them "excited." As the gases return to their normal state, they emit photons, small bursts of energy in the form of light. When a large number of electrons bombard the atmosphere, the oxygen and nitrogen can emit enough light for the eye to detect.

The Sun provides the energy for the aurora through the solar wind, a stream of electrically charged particles flowing out in all directions. As these

particles approach Earth, they interact with our magnetic field and transfer energy into the space around the planet. Then the electrons trapped around Earth slide down magnetic field lines into the atmosphere, mostly around the north and south poles.

Because of the constant breeze of solar wind particles, auroral displays occur nearly every night between 60 degrees and 70 degrees latitude, where Earth's magnetic field connects to the planet. Nightly light shows are one of the privileges of living in the frigid extremes of Canada, Alaska, Scandinavia, and Russia, and at the far edges of New Zealand, Chile, and Antarctica.

The color of the aurora depends on which gas is being excited by the electrons, and on how excited it becomes. The color also depends upon how fast the electrons are moving, or how much energy they have at the time of their collisions. Oxygen glows green, white, or red, and nitrogen shows blue and purple. The different shapes of the aurora are a mystery that scientists are still trying to unravel.

During more intense periods of solar activity, auroras descend to lower latitudes, appearing over such cities as Boston, Minneapolis, or Edinburgh about fifteen to twenty times per year. Perhaps once per solar cycle, the aurora can be viewed most of the way toward the equator, as it was in 1909 when the most potent magnetic storm on record brought an aurora to Singapore. Great auroras like these are the sort that inspired Norse warriors and Greek philosophers; the kind that led campers in the Appalachian Mountains in March 1989 (page 176) to believe a nuclear war had begun.

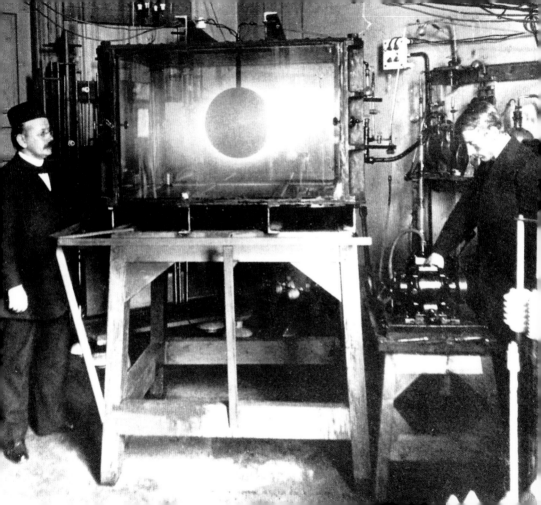

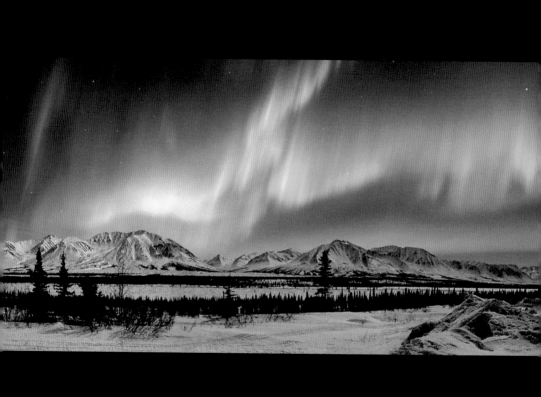

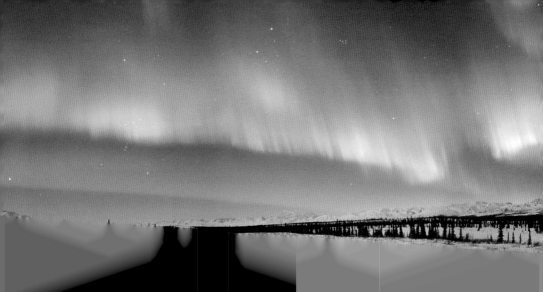

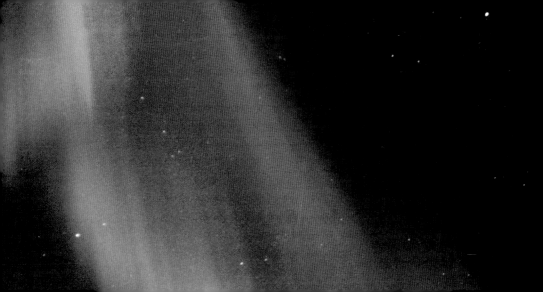

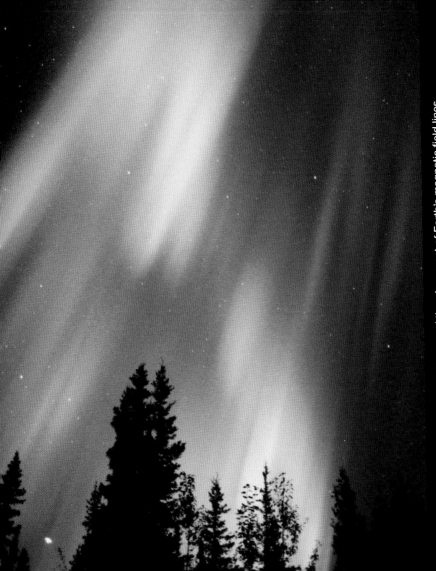

↑↑ The northern lights reveal the placement of Earth's magnetic field lines, attracting charged electrons the way a magnet attracts iron filings.

↑ Yellow and red curtains draw their colors from the oxygen in the atmosphere, which is chemically excited by the impact of high-energy particles.

123

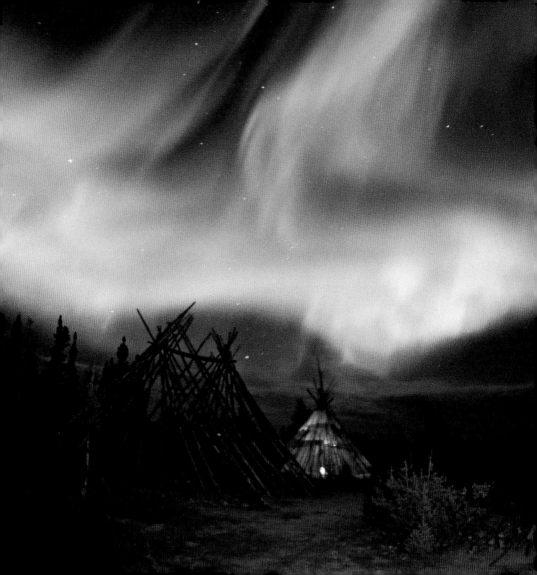

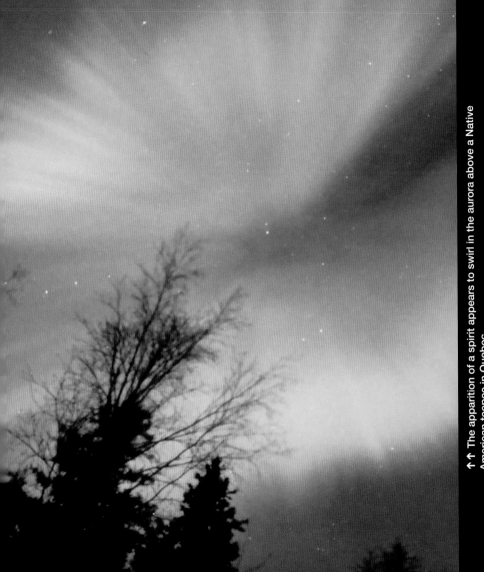

↑↑ The apparition of a spirit appears to swirl in the aurora above a Native American teepee in Quebec.

↑ Auroras sometimes appear to spread out from a single point overhead in a pattern called a "corona."

125

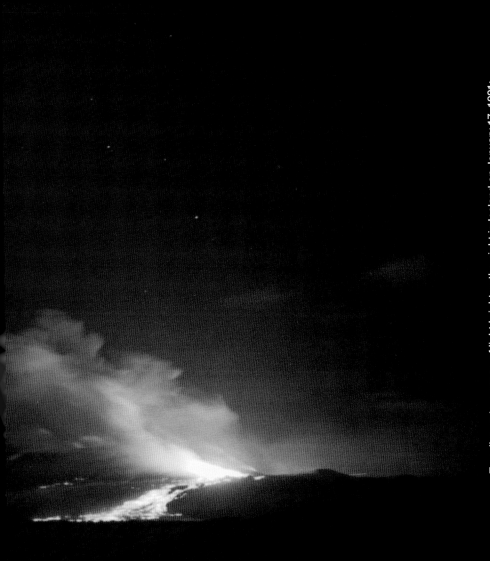

Two disparate sources of light brighten the night in Iceland on January 17, 1991: The northern lights dance while Mount Hekla erupts with lava.

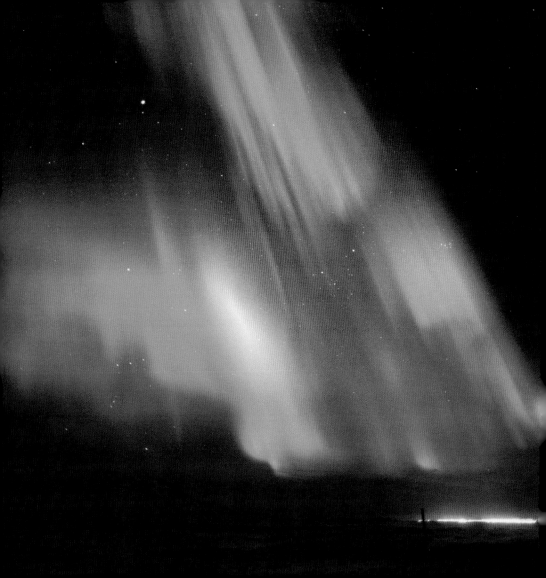

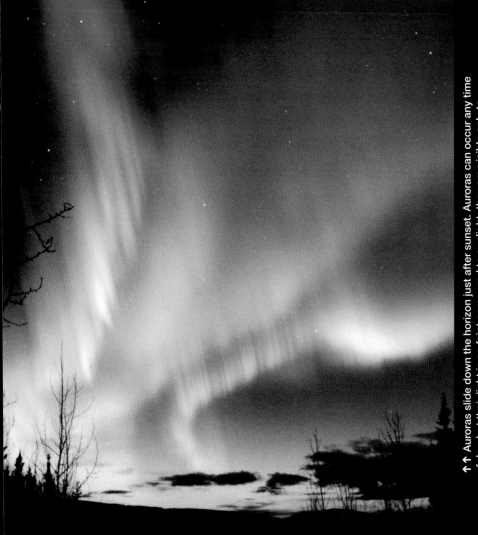

↑↑ Auroras slide down the horizon just after sunset. Auroras can occur any time of day, but their light is so faint compared to sunlight, they are visible only to scientific instruments by day.

↑ Green bands of night light greet the end of another day.

129

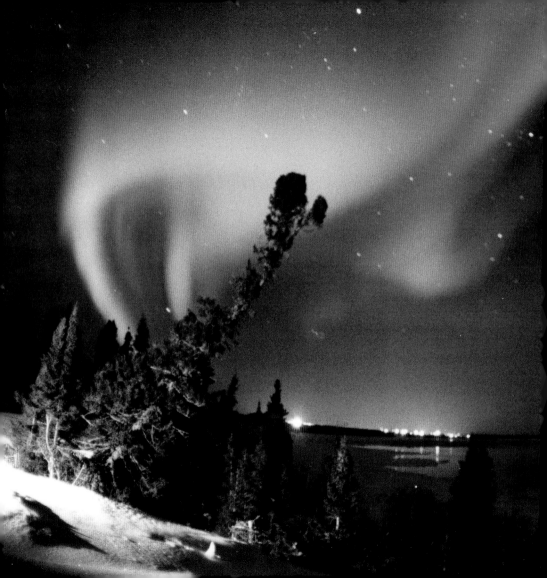

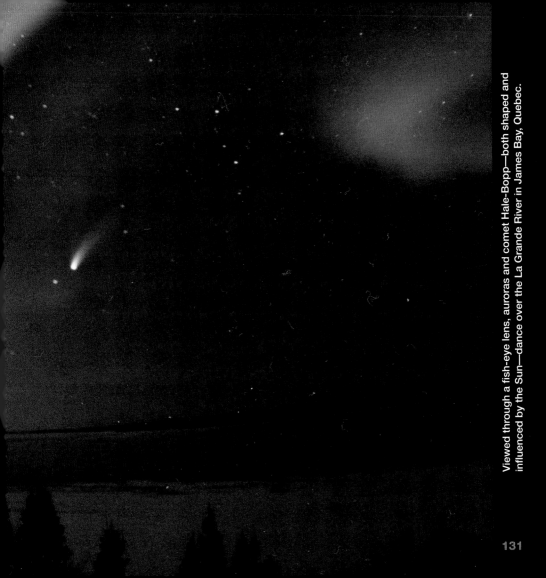

Viewed through a fish-eye lens, auroras and comet Hale-Bopp—both shaped and influenced by the Sun—dance over the La Grande River in James Bay, Quebec.

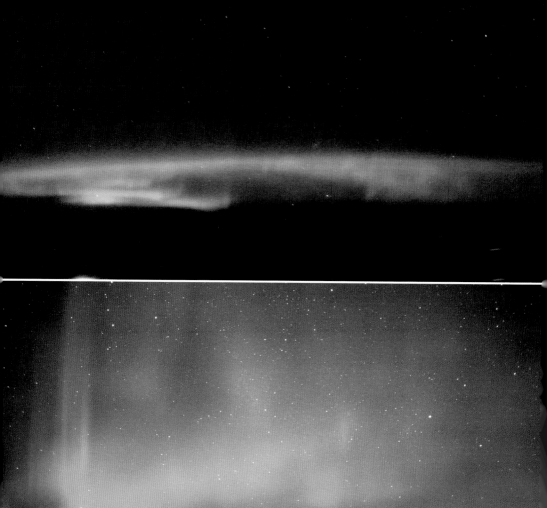

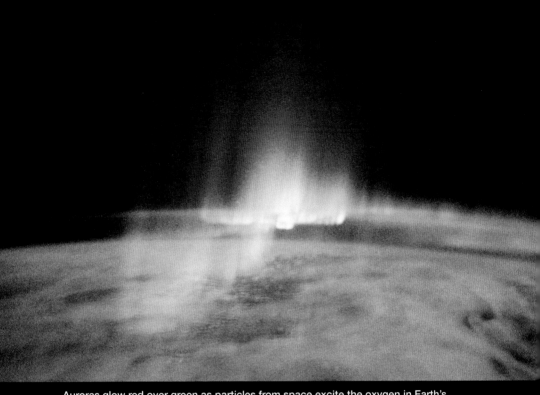

Auroras glow red over green as particles from space excite the oxygen in Earth's atmosphere to different energies at different altitudes. Auroras can form anywhere from 60 to 250 miles up, sometimes spanning nearly all of that distance.

← Photographers captured simultaneous images of the same aurora from space and Earth. Space station astronaut Don Pettit coordinated the position and timing with ground-based photographer Pekka Parviainen on March 31, 2003, at about 20:50 GMT.

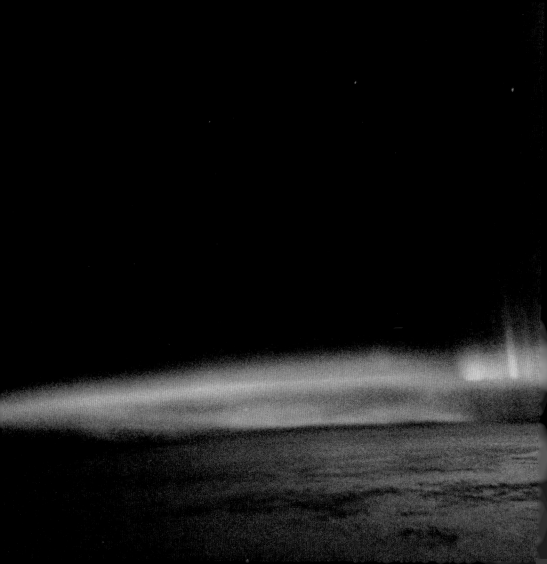

Astronauts on the space shuttle *Discovery* captured the stream of particles crashing into the top of Earth's atmosphere on June 1, 1999.

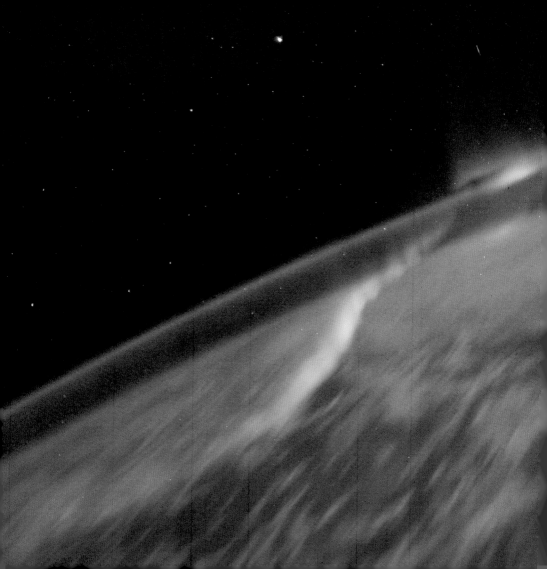

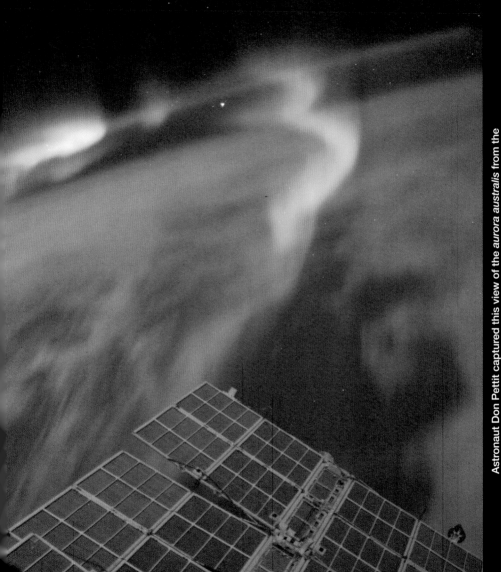

Astronaut Don Pettit captured this view of the *aurora australis* from the International Space Station in June 2003. Like the solar panels of the station, the Earth's atmosphere captures energy raining down on the planet from the Sun.

137

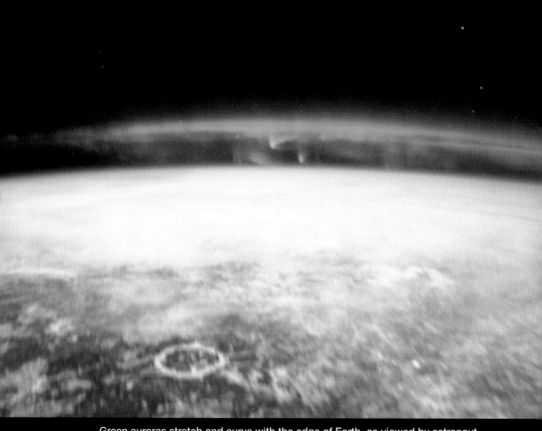

Green auroras stretch and curve with the edge of Earth, as viewed by astronaut Don Pettit on the International Space Station. The circle in the foreground is an old impact crater on Earth.

→ The Polar satellite captured this view of both of Earth's auroral crowns in ultraviolet light. The UV light also glows as it bounces around the atmosphere on the sunlit side of the planet.

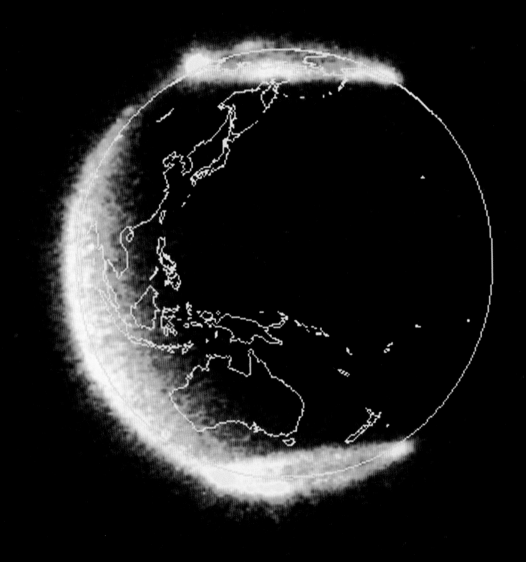

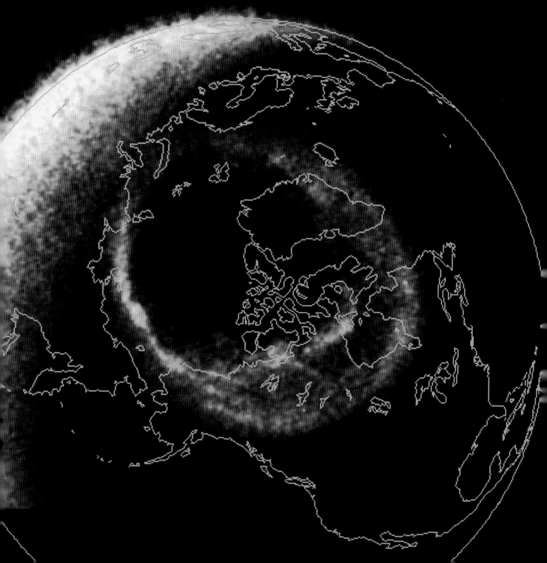

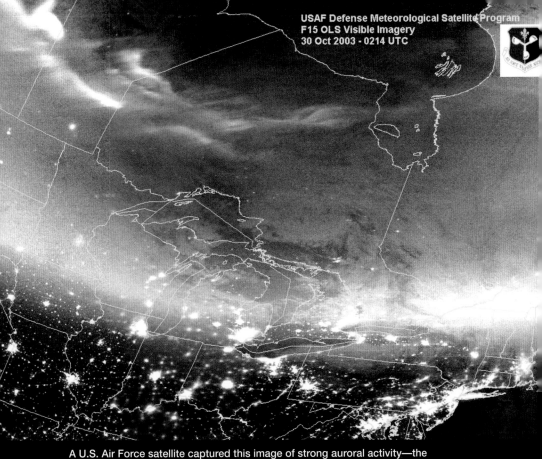

A U.S. Air Force satellite captured this image of strong auroral activity—the fuzzy white band stretching from left to right—hovering over the city lights of North America in October 2003.

← NASA's Polar satellite captured this view of the ring of auroral activity around Earth's north magnetic pole, where the great magnetic field of the planet dips down toward the surface. Excited electrons from space follow these field lines down into the atmosphere, making ovals of auroras.

141

Our Star, the Sun

Give me the splendid silent Sun
with all his beams full-dazzling, . . .

Walt Whitman, LEAVES OF GRASS

Sunlight forms a starburst pattern against the black of space, the blue of
the ocean, and the white-gray robotic arm of the space shuttle *Endeavour*
during mission STS-77 in June 1996.

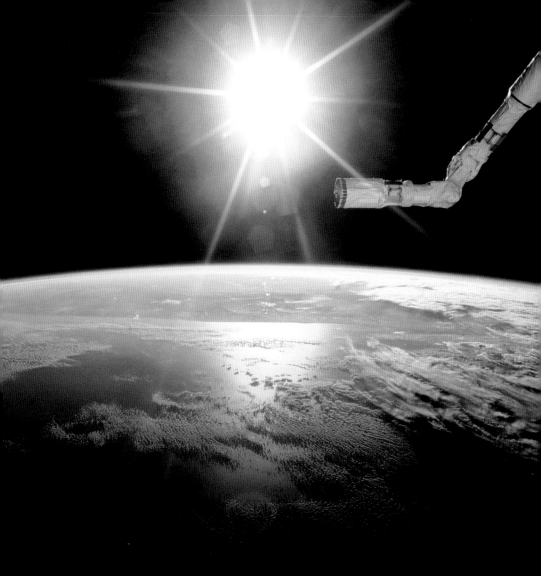

IN ASTRONOMICAL TERMS, the Sun is just a middle-aged, middle-sized gas ball that is one of 100 billion stars in the Milky Way. But it is the only star we can study up close, and the only one that affects life on Earth.

The Sun is by far the largest object in our neighborhood, making up nearly 99 percent of the mass of the solar system. It would take more than a hundred Earths lined up to span the width of the Sun, and more than a million Earths could fit inside. Atomic particles need as much as 170,000 years to bounce from the core of our star to the visible surface.

The Sun is almost entirely made up of the most basic of all elements: hydrogen, which accounts for 92 percent of its atoms. That simple element becomes nuclear fuel inside the Sun, where conditions are so extreme that atoms are broken into their constituent parts—protons and electrons. This electrified hydrogen represents a fourth state of matter (besides solid, liquid, and gas) that scientists call plasma.

The pressure in the Sun's core is 250 billion times more intense than what we experience on Earth; the density is ten times the density of gold; and temperatures approach 16 million°C (29 million°F). The particles are so closely packed together and moving so fast that they collide incessantly and combine in a fusion reaction that we would love to replicate on our energy-hungry Earth.

Every second, 700 million tons of the Sun's hydrogen is fused into 695 million tons of helium and a few other trace elements. About five million tons of mass is lost along the way, being converted to energy that eventually reaches Earth as sunlight, solar wind, and other forms of solar radiation.

From our perspective on the ground, this endless nuclear explosion appears static. The Sun is a yellowish-white light bulb that doesn't burn out or dim, at least so far as the naked eye can tell. It barely seems to change from

sunrise to sunset, from year to year. Yet when we look at our star closely, with the tools of science, we see that it is dynamic and variable, with spasms and cycles that can last from seconds to centuries.

By using special telescope filters and cameras, scientists can isolate different forms of light and different temperatures. Extreme ultraviolet light and X-rays expose the tenuous, superheated plasma of the corona as it builds magnetic prominences and explodes with flares. White light, hydrogen alpha, and calcium filters reveal the white and colored faces of the Sun—the photosphere and the chromosphere, respectively—where sunspots and filaments blemish the surface like pimples and wrinkles. Scientists can observe the radio waves and sound waves (page 151) pulsing out of our star, exposing the granulated, roiling surface where superheated gas bubbles rise up like boiling water. Magnetic images of the Sun (pages 153 and 199), or magnetograms, show pairs of poles poking out from the interior of the Sun and changing visible light into other forms of radiation.

Viewed with these different eyes over time, we can see the Sun wax and wane with activity. The number of sunspots—and the explosions that go with them—rises and falls every eleven years. This breathe-in-breathe-out rhythm has been recorded since at least the time of the ancient Greeks and Romans, and may have been going on for as long as the Sun has been smashing atoms. The last peak of activity, or "solar maximum," occurred in 2000–01.

The cycles of solar activity seem to be at least partly due to a quirk of the Sun's spin. On the whole, the Sun makes a complete rotation once every 27 days. But in fact, the surface of the Sun at its equator makes a full rotation in as little as 25 days, while the surface at the north and south poles can take as long as 36 days to spin once around.

The flow of electrified gas—matter and energy moving from the core to the surface, east and west, all at different speeds—winds the magnetic field into a tangled mess of loops and knots. Magnetic fields are like rubber bands, having both tension and pressure, and they can be strengthened by stretching, twisting, and folding. When wound by this rotation, the Sun's magnetic field lines poke out from the interior and into its mysterious atmosphere, or corona.

This swirling mess of magnetism generates long, tubelike arches of nuclear plasma—prominences—stretching over, under, and around each other and hanging suspended above the surface. Magnetic loops rise 300,000 miles into space before dipping back down into the Sun. Huge bubbles occasionally erupt and spew 100,000 battleships worth of material into space at a million miles an hour. All of this electrified gas rages at one to five million degrees—hotter than the 6,000°C (10,000°F) surface below.

The turbulent surface of the Sun gives hints as to how the arches are built. Granulations and bubbles percolate on the visible surface of the Sun, venting energy from inside. Sunspots darken the bright background, as they are cooler (3,800°C or 6,800°F) than the regions around them. But they are also regions of intense, complicated magnetic activity, with magnetic fields a thousand times the strength of Earth's field. Scientists suspect this magnetic potency is what makes them cool: the energy of the Sun is being transformed into magnetism instead of light and heat.

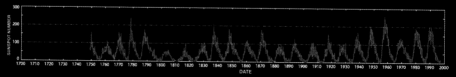

This graph plots three hundred years of sunspot numbers, showing the rhythmic rise and fall of solar activity.

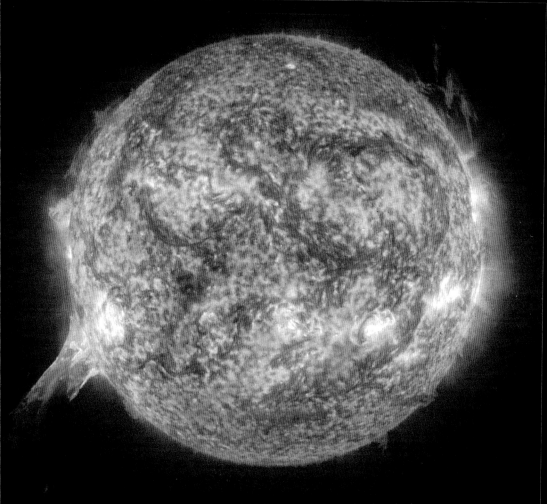

The Sun, viewed in extreme ultraviolet light by the Solar and Heliospheric Observatory (SOHO), tosses a curling prominence into space (bottom left). Bright spots mark "active regions" where sunspots, flares, and coronal mass ejections form.

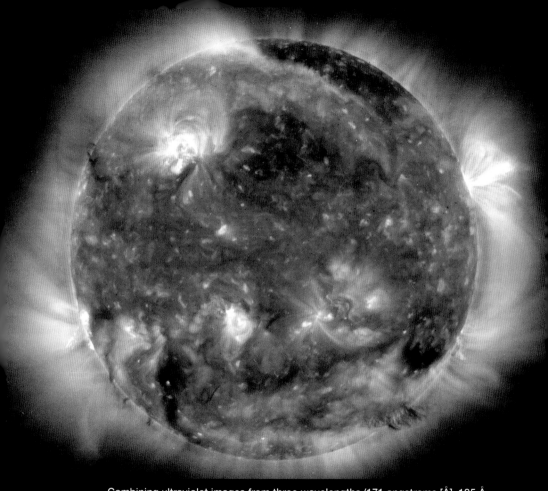

Combining ultraviolet images from three wavelengths (171 angstroms [Å], 195 Å, and 284 Å) gives three-dimensional depth to the Sun's corona, or atmosphere, where gnarled magnetic field lines poke out of the Sun. The colors of the image are not true colors of the Sun—the digital images are actually taken in black-and-white, then color coded into red, yellow, and blue based on the wavelength

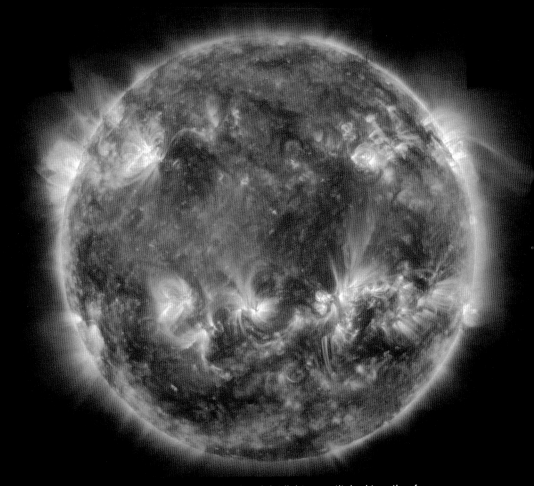

This composite image of the Sun in ultraviolet light was stitched together from 25 separate close-ups captured by NASA's Transition Region and Coronal Explorer (TRACE) satellite. The satellite has captured the most detailed, tightly focused images of the Sun ever taken, particularly the thin, wispy tubes of plasma hanging in the atmosphere.

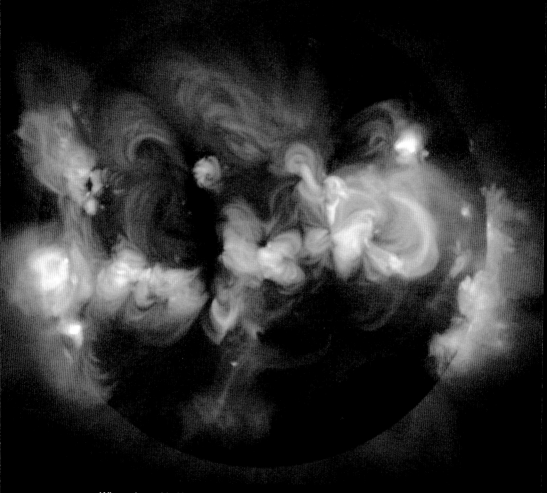

When viewed in X-ray emissions, the Sun reveals its hottest and coolest sources of radiation—flares and sunspots. Material in the corona has to be heated to three million degrees to produce the X-rays, observed by Japan's Yohkoh satellite.

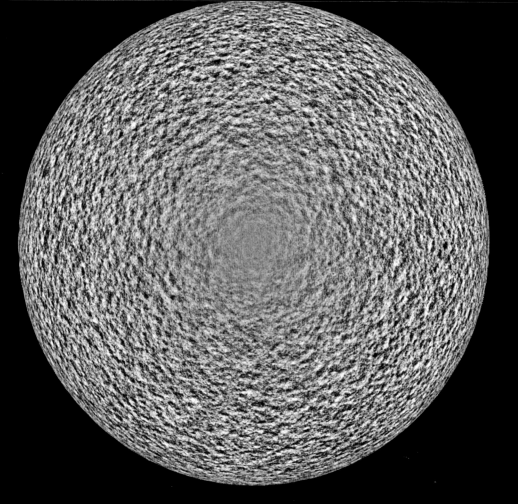

Using the Michelson Doppler Imager on SOHO, solar physicists can detect sound waves from inside the sun to create images of the star's surface. The orange-peel texture comes from narrow plumes of hot plasma rising by convection from the solar interior.

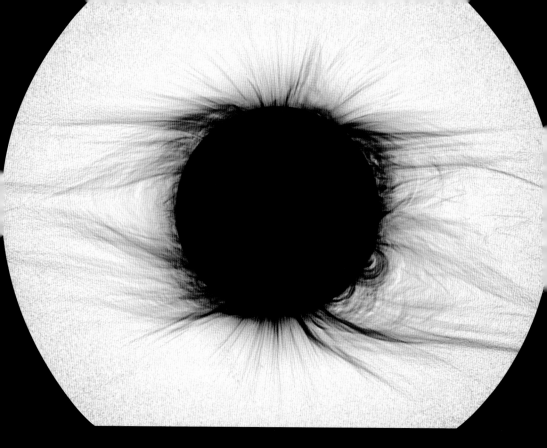

High-contrast techniques were used to tease out the fine
magnetic structures and streamers of solar plasma arising from
the corona as viewed by a ground-based telescope during a
1998 eclipse.

→ Magnetograms expose clusters of intense magnetic activity.
Note the pairing of black and white areas, indicating adjacent north
and south magnetic polarity. Sunspots form in these active regions.

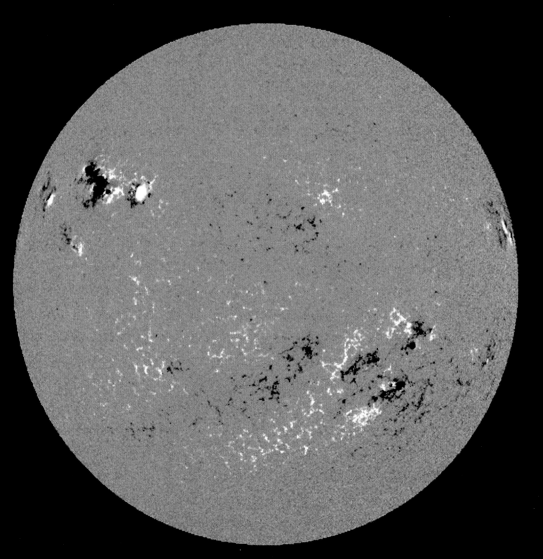

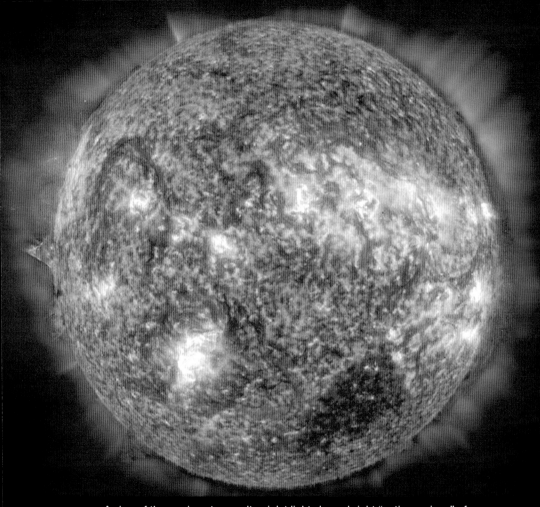

A view of the sun in extreme ultraviolet light shows bright "active regions" of magnetic activity, likely related to sunspots, and wisps of the solar atmosphere and wind stretching away from the visible surface.

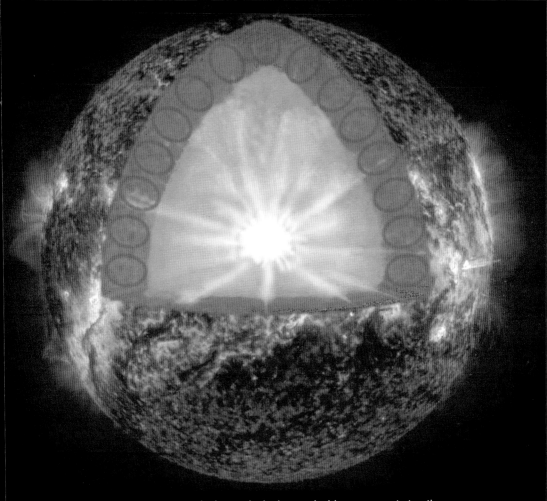

This artistic cutaway reveals three principal zones inside our nearest star: the inner core, the transition zone (where energy and particles begin their ascent toward the surface), and the convection zone where energy circulates like water bubbling in a pot.

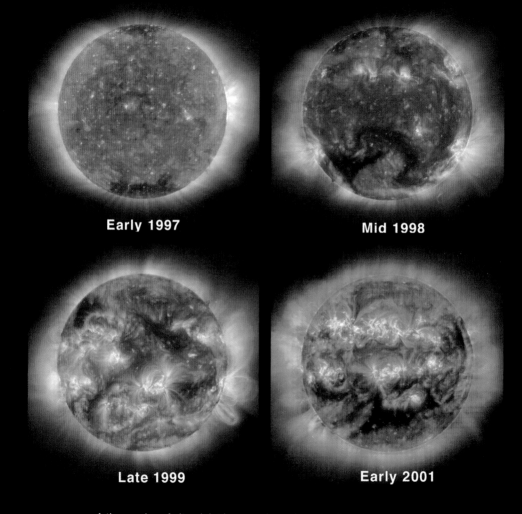

Early 1997

Mid 1998

Late 1999

Early 2001

A time-series of ultraviolet images shows how the Sun changed from relative calm to a bright, tangled mess of magnetic loops in the years leading up to solar maximum—the peak of the Sun's 11-year cycle of activity.

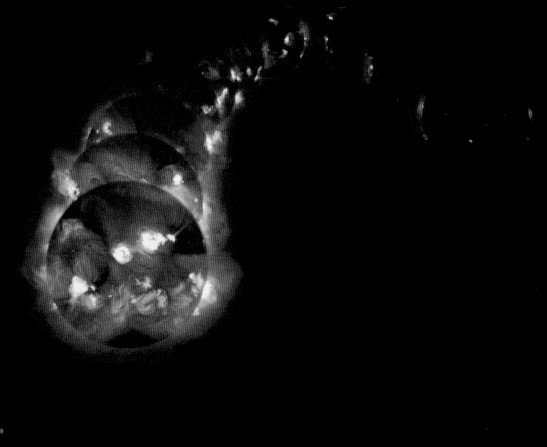

Twelve X-ray images of the Sun were collected by the Yohkoh satellite (one every 90 days) from 1991 to 1995 to portray how the Sun changes from solar maximum (bright orange) to solar minimum (mostly dark and quiet).

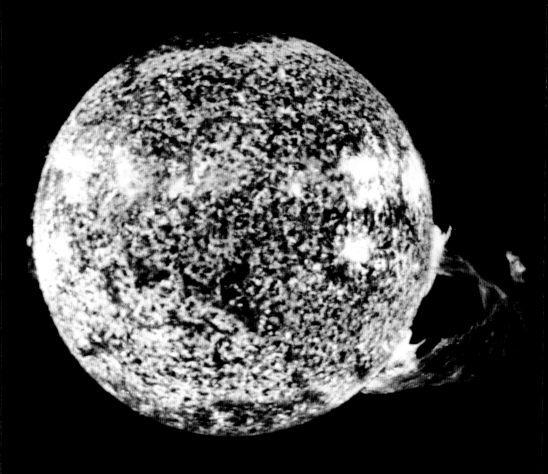

The Skylab space station of the 1970s included some of the first solar observing instruments ever carried into space. In December 1973, using the UV camera onboard, scientists captured the largest solar prominence ever observed, spanning more than 365,000 miles.

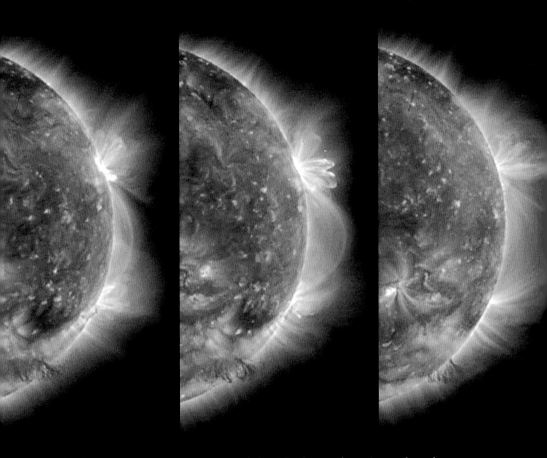

This time-series, taken over a span of about five hours, shows two active solar arcades (bright regions at 2 o'clock and 4 o'clock) as they make and expand a magnetic connection (faint arch at 3 o'clock).

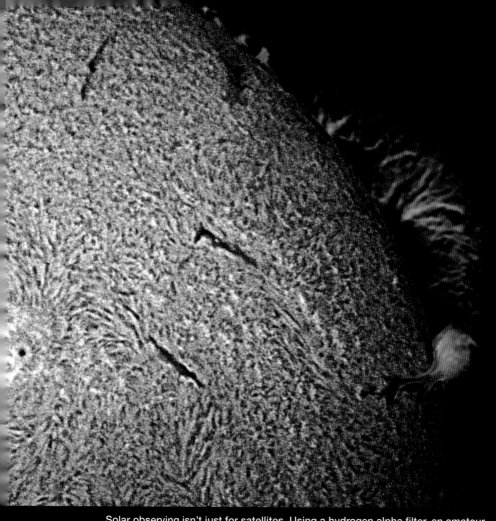

Solar observing isn't just for satellites. Using a hydrogen alpha filter, an amateur astronomer collected this image of a solar prominence (big loop on the right) and several filaments (dark lines) along the mottled surface of the Sun.

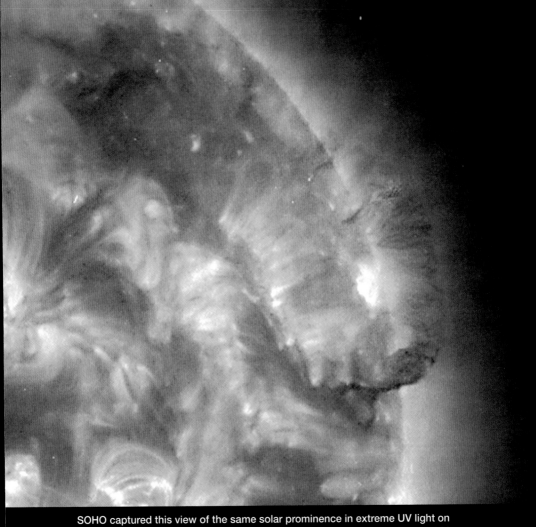

SOHO captured this view of the same solar prominence in extreme UV light on January 21, 2004. Note the coil or springlike twists of the magnetic loops within the prominence.

161

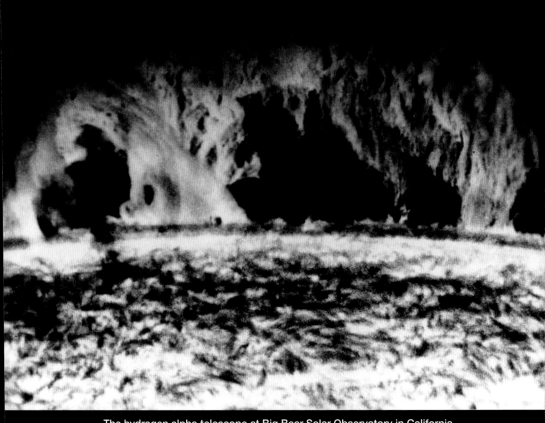

The hydrogen alpha telescope at Big Bear Solar Observatory in California observed this massive prominence in 1970. Prominences are extremely hot loops of electrically charged gases visible in ultraviolet and other wavelengths of light, but not in simple white light.

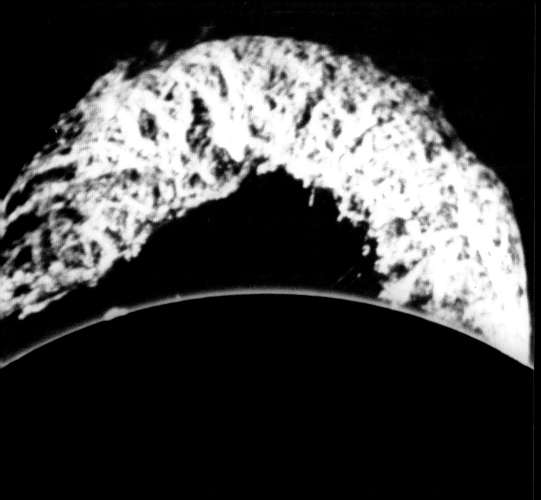

This prominence in June 1946 reached all the way to Hollywood. Director Frank

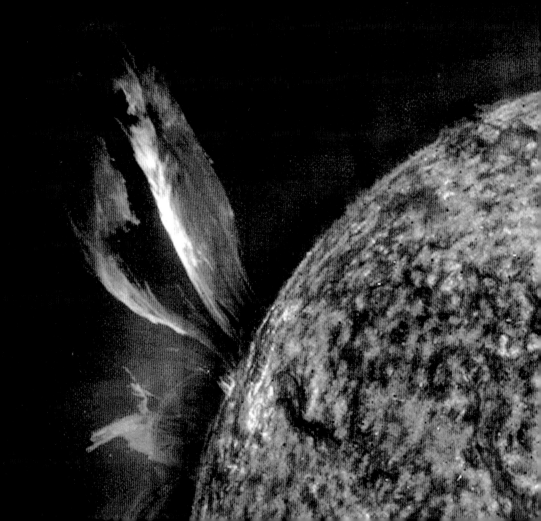

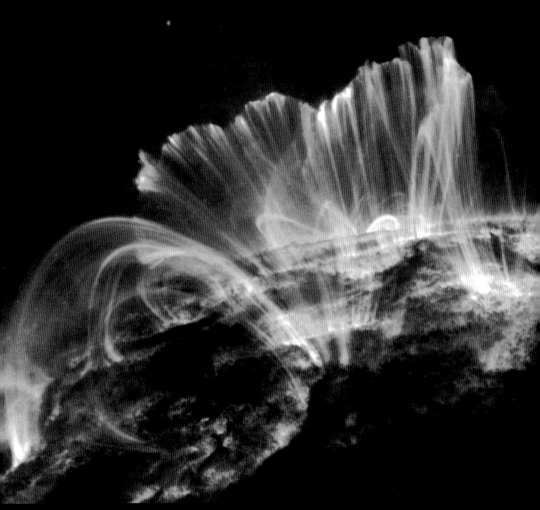

The tight close-up images from the TRACE satellite show the individual

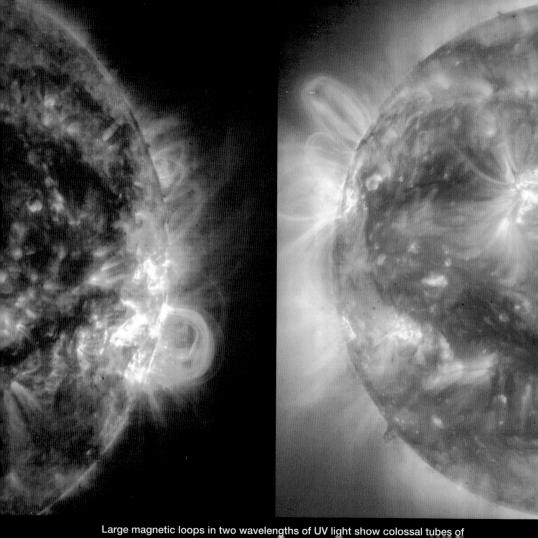

Large magnetic loops in two wavelengths of UV light show colossal tubes of

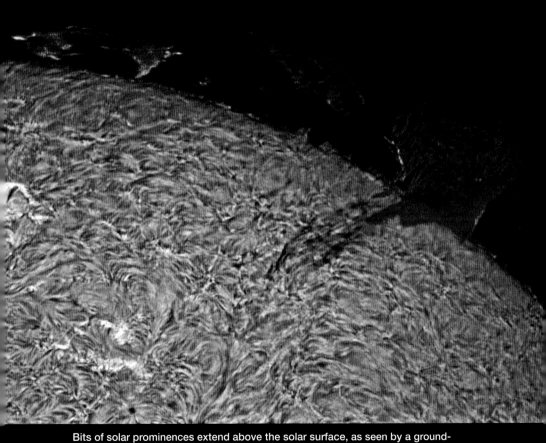

Bits of solar prominences extend above the solar surface, as seen by a ground-based telescope with a hydrogen-alpha filter.

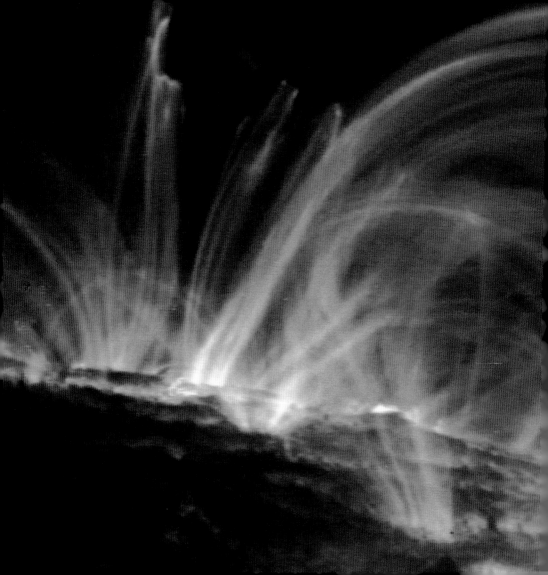

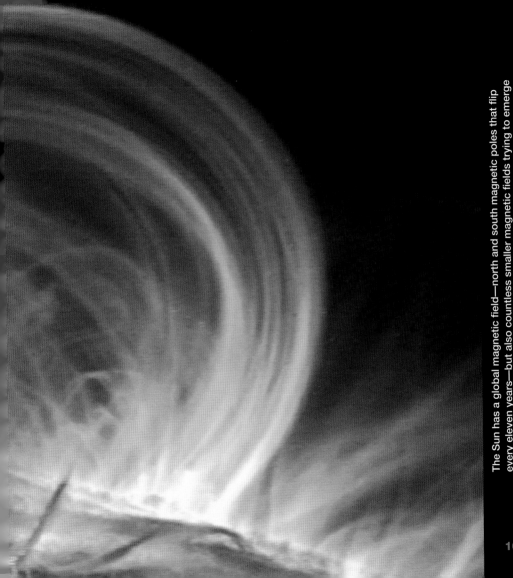

The Sun has a global magnetic field—north and south magnetic poles that flip every eleven years—but also countless smaller magnetic fields trying to emerge from all parts of the star.

169

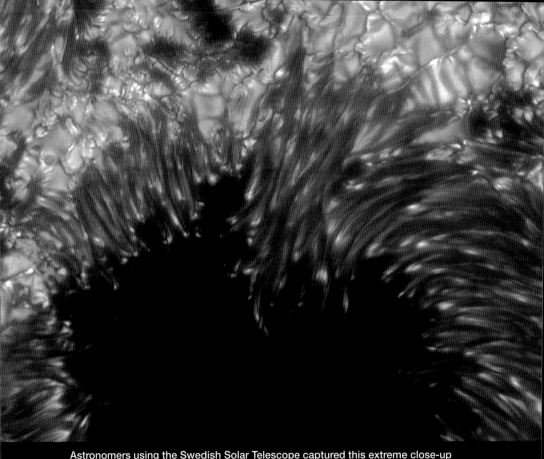

Astronomers using the Swedish Solar Telescope captured this extreme close-up of a sunspot and the filament channels surrounding it on July 15, 2002. Sunspots appear darker than the Sun's surface because they are cooler (3,800° F, compared to 6,000° F for the rest of the surface).

← The magnetic loops in the solar corona are like rubber bands that can be stretched and twisted until they break, releasing hot plasma and energy into the solar system.

171

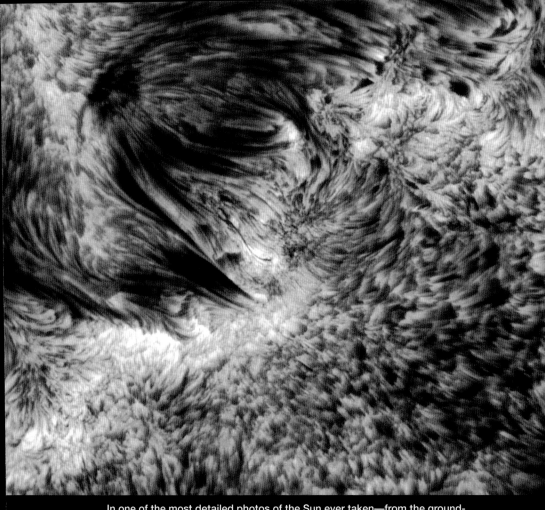

In one of the most detailed photos of the Sun ever taken—from the ground-based Swedish Solar Telescope—scientists observed a carpet full of individual spicules, or pipes, of hot plasma moving at 30,000 miles per hour.

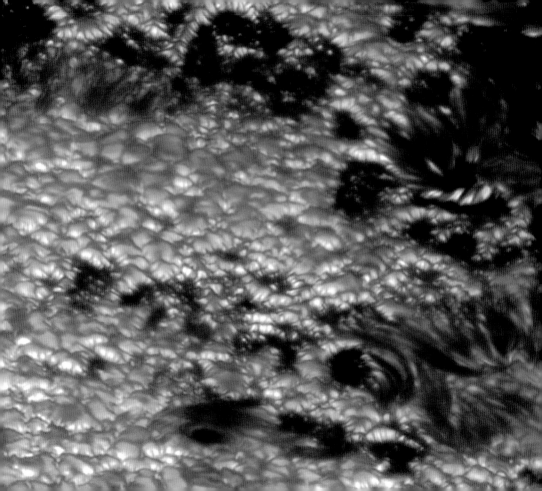

The Weather Out There Is Frightful

Wear sunscreen. If I could offer you only one tip for the future, sunscreen would be it. The long-term benefits of sunscreen have been proved by scientists, whereas the rest of my advice has no basis more reliable than my own meandering experience.

Mary Schmich, *CHICAGO TRIBUNE,* JUNE 1997
(ERRONEOUSLY ATTRIBUTED TO KURT VONNEGUT, JR.)

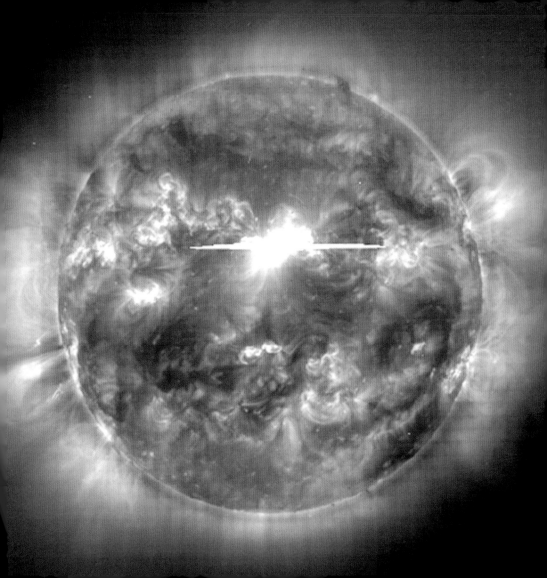

ON MARCH 13, 1989, the U.S. Department of Defense tracking system that kept tabs on 19,000 satellites and bits of space debris orbiting Earth briefly lost track of 11,000 of them. When those objects reappeared, 1,500 had slowed and dropped several miles in altitude. On that same night, radio listeners who tuned in from Minnesota heard the broadcasts of the California Highway Patrol. In New Jersey, a $36 million transformer was burned up by a surge of extra current in the power lines. But that was mild compared to what happened in Quebec, where a blackout left six million people without electricity for nine hours—some for months—in the middle of winter. And awestruck and wary residents of Florida, Mexico, and the Cayman Islands saw glowing curtains of light in the sky.

All of these bizarre events were catalyzed by storms on the Sun. A series of solar explosions launched blobs of hot, electrified gas toward Earth and stirred up the second largest "magnetic storm" on record. More than 1,500 gigawatts of electricity poured into the atmosphere, double the power-generating capacity of the entire United States.

The event was unusual in its strength and effect, but not uncommon in its occurrence. The Sun has changeable weather, constantly roiling with the cosmic equivalent of winds, clouds, tornadoes, and hurricanes. Our planet resides within the atmosphere of a stormy star, an atmosphere that stretches to the edge of the solar system and pushes against the stardust of the Milky Way galaxy. Gusty streams of plasma continuously blow out from the Sun, and some rain down on Earth and the other planets. More energy escapes the Sun in its storms than humans have consumed in the entire history of civilization.

And while these storms do not harm life on Earth, they do affect the way we live. Space weather, as scientists call it, distorts and disturbs twenty-first-

century technologies, bringing the power of the Sun down to Earth. A range of disturbances develop in our star's magnetically twisted innards, erupt from the atmosphere, rush across interplanetary space, and disturb the environment around our planet. The shock waves can disrupt and sometimes destroy objects that use electromagnetism—everything from cell phones, satellites, electric power grids, and radios to butterflies and turtles that navigate by Earth's magnetic field.

Sunspots were long thought to be the cause of space weather, as they are almost always visible on the surface of the Sun when auroras and magnetic storms arise. Sunspots tend to appear in groups, paired with kin of opposite magnetic polarity. They can last from several hours to several months, and they can be as large as twenty times the size of Earth. The active regions above sunspots emit X-rays and radio waves that hinder radio communication on Earth. But mostly, the spots are visible signals of where the next solar blast might lift off.

The most familiar solar tempest is the flare, a sudden, intense flash near the visible surface of the Sun. Flares occur when magnetic energy built up in the solar atmosphere is suddenly released in a burst equivalent to millions of hydrogen bombs. These explosions produce X-rays, microwaves, and seismic shock waves that heat and ripple the Sun's surface. Flares energize the particles in the corona, cooking them to tens of millions of degrees and accelerating them to a point where radio waves, X-rays, and gamma rays are shot across the solar system. Fortunately, most of the particles are deflected by Earth's magnetic field, and our atmosphere absorbs nearly all the harmful radiation.

Flares can have a crippling effect on space-related activities. The onslaught of radiation heats Earth's upper atmosphere and causes increased friction that

can drag satellites down from their orbits prematurely. (The Skylab space station was a victim of such space weather.) Long-distance signals—such as the radio frequencies used by ships, planes, and satellites—can be disrupted and sometimes blacked out by the disturbance of the space around Earth.

High-energy particles accelerated in solar flares can pierce the sensitive electronics and microchips of satellites—and the tissues of humans. Astronauts working in space need to take cover when flares erupt, lest they receive the equivalent of dozens to hundreds of medical X-ray doses. In August 1972, a solar flare (page 181) burst with such intensity that it likely would have killed the Apollo astronauts had they been on the Moon. NASA constantly monitors space weather, and figuring out how to shield astronauts from such blasts will be a critical hurdle to sending humans to Mars.

If solar flares are like tornadoes—extremely intense but short-lived and localized—then coronal mass ejections (CMEs) are like hurricanes. A CME is the eruption of a huge bubble of plasma from the Sun's atmosphere. Essentially, the corona rips open and blasts as much as 100 billion tons of material into space at one to five million miles per hour. Just hours after blowing into space, these huge magnetic clouds grow to dimensions far exceeding those of the Sun itself, often as wide as thirty million miles across. As it plows into the solar wind, a CME can create a shock wave that accelerates particles toward planets, asteroids, and any other object—such as a satellite or astronaut—in its path. If a CME erupts on the side of the Sun facing Earth, the results can be spectacular.

And yet this cloudburst would not ruffle the hair on your head because its mass is quickly spread out in three-dimensional space to a point where it has fewer particles per cubic inch than the best vacuums scientists can make on

Earth. The power of a CME lies in its ability to drive currents in Earth's magnetic field and to energize the hot gas that already surrounds the planet.

Our planet's magnetic cocoon, known as the magnetosphere, keeps almost all of a CME's harmful radiation and particles from reaching us. Less than one percent of the particles from the Sun penetrate the magnetosphere, but that is enough to act as a cosmic generator, producing several million amps of electric current. These cosmic clouds can create beauty—auroras usually accompany a CME—and havoc, as people learned in March 1989.

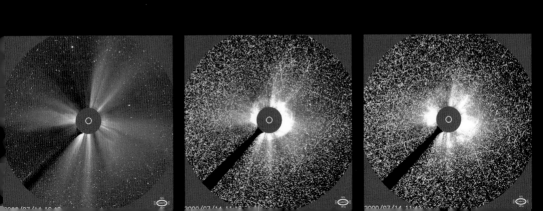

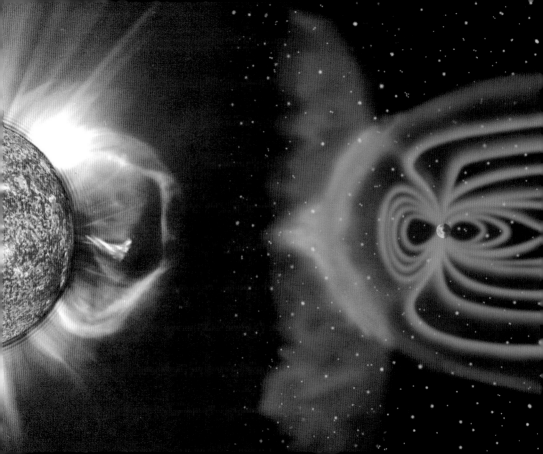

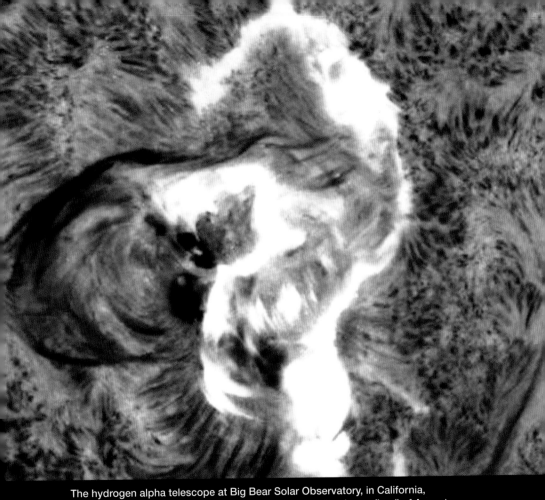

The hydrogen alpha telescope at Big Bear Solar Observatory, in California, captured this photograph of the forty-million-degree "seahorse flare" of August 7, 1972, between the launches of Apollo 16 and 17. The event spewed solar particles and X-rays so intense that the astronauts could have been killed had

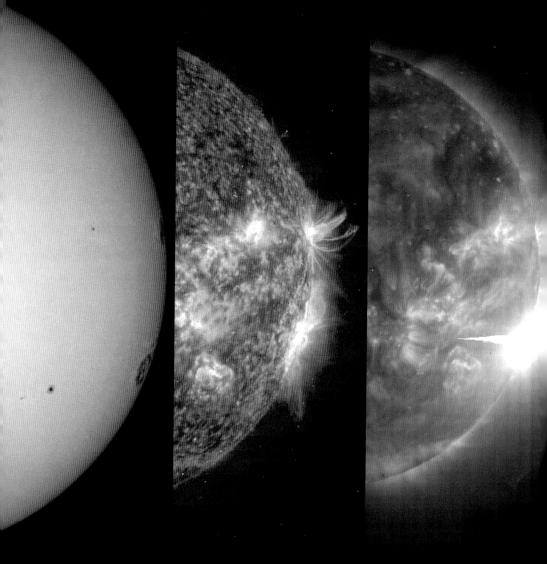

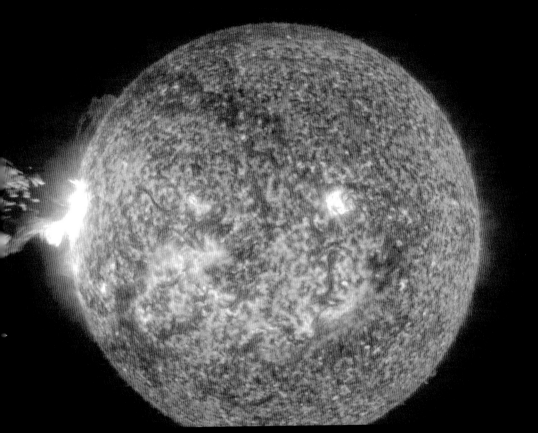

A coronal mass ejection lifts off the side of the sun in July 2005, just as the active region rotates over the limb into view from Earth. This helium 304 Å (spectral line) view shows the state of the solar plasma at roughly 60,000°C.

← Three different imagers on the SOHO satellite captured these views of the Sun on November 4, 2003, at the time of the largest X-ray flare ever recorded. The first image shows a large sunspot (at 4 o'clock) that became the source of the flare; the second shows the active region, with its swirling magnetic activity in profile; the third shows the bright flash of the flare itself.

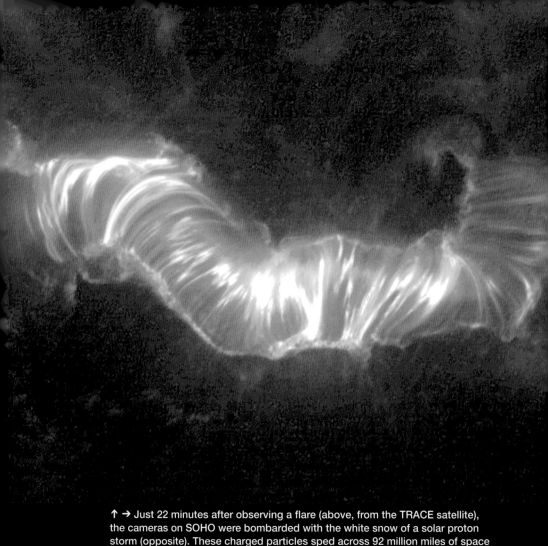

↑ → Just 22 minutes after observing a flare (above, from the TRACE satellite), the cameras on SOHO were bombarded with the white snow of a solar proton storm (opposite). These charged particles sped across 92 million miles of space to temporarily flood and disable the camera.

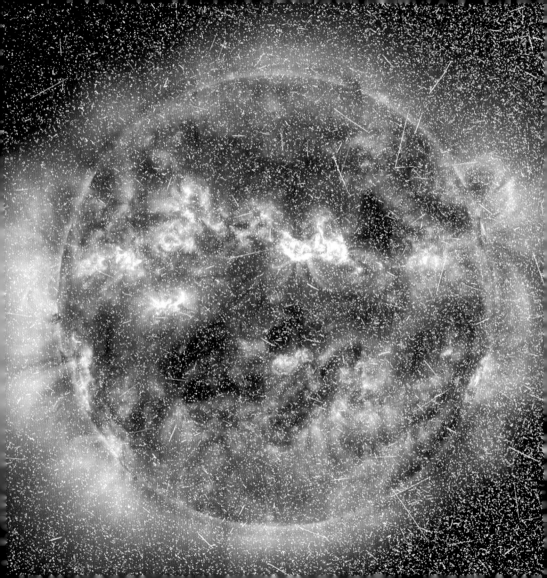

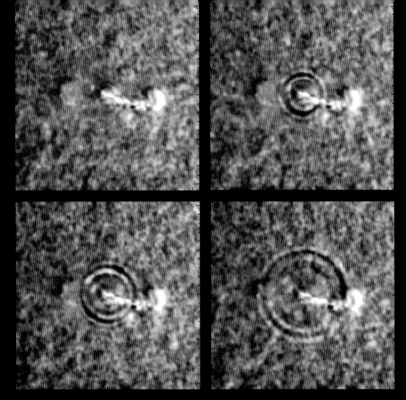

↑ This time-series from SOHO's Michelson Doppler Imager shows the ripplelike flow of energy across the visible surface of the Sun following a solar flare on July 6, 1996. This solar quake spread across more than 60,000 miles of the Sun's face as it sent seismic waves through the interior.

→ The Large Angle Spectrometric Coronagraph, or LASCO, an instrument on SOHO, captured this view of a CME blasting billions of tons of matter out of the solar atmosphere into space at millions of kilometers per hour. An extreme ultraviolet view was enlarged and superimposed over the LASCO image to show

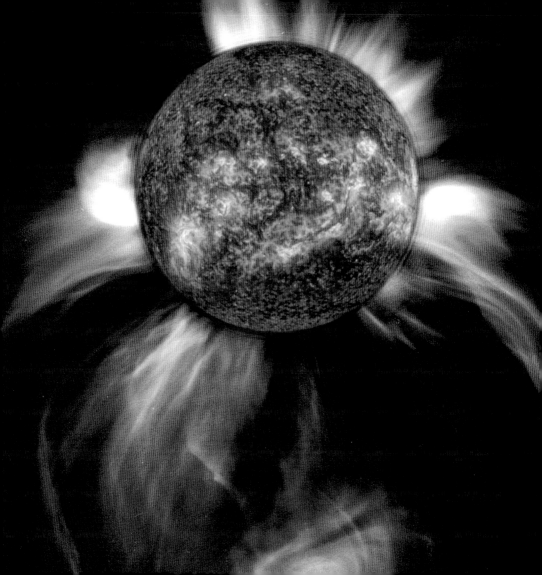

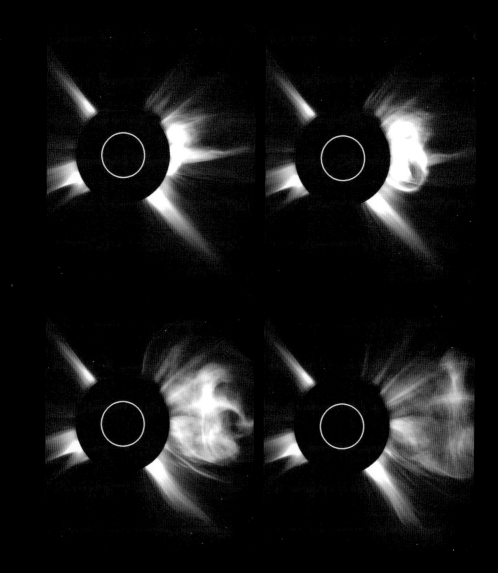

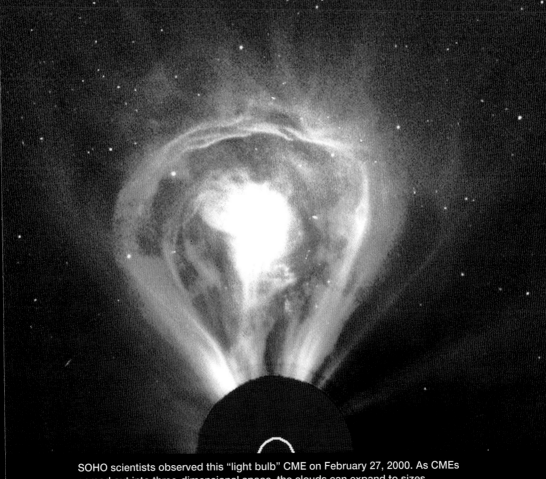

SOHO scientists observed this "light bulb" CME on February 27, 2000. As CMEs spread out into three-dimensional space, the clouds can expand to sizes rivaling the dimensions of the Sun itself, though the particles in this solar breeze are so spread out that they wouldn't ruffle the hair on your head.

← This LASCO series, taken over the course of two hours, shows a CME rocketing into space.

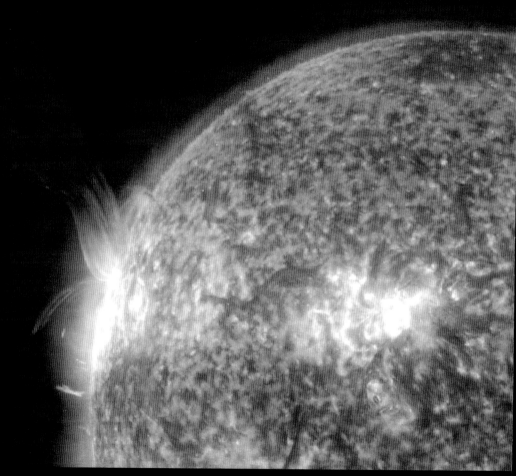

An unusual CME blast on November 14, 1999, appeared to shoot particles out in straight lines rather than in the typical balloon-shaped arcs of most ejections.

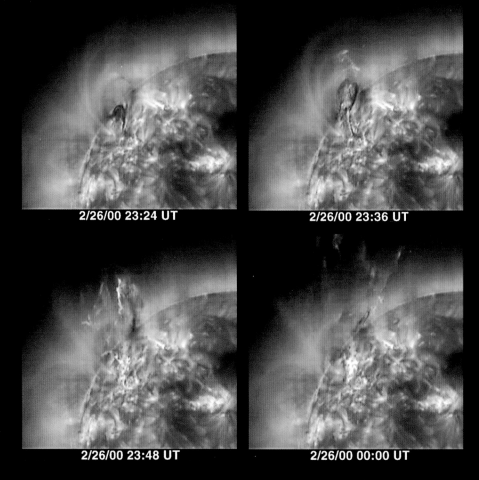

2/26/00 23:24 UT

2/26/00 23:36 UT

2/26/00 23:48 UT

2/26/00 00:00 UT

A time-series from SOHO's Extreme-ultraviolet Imaging Telescope (EIT) captured the wispy arcs and lines of a solar magnetic field as they broke open to launch a CME on February 26, 2000.

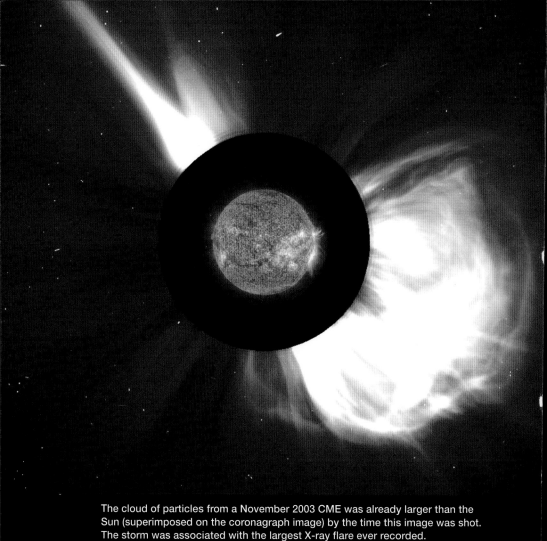

The cloud of particles from a November 2003 CME was already larger than the Sun (superimposed on the coronagraph image) by the time this image was shot. The storm was associated with the largest X-ray flare ever recorded.

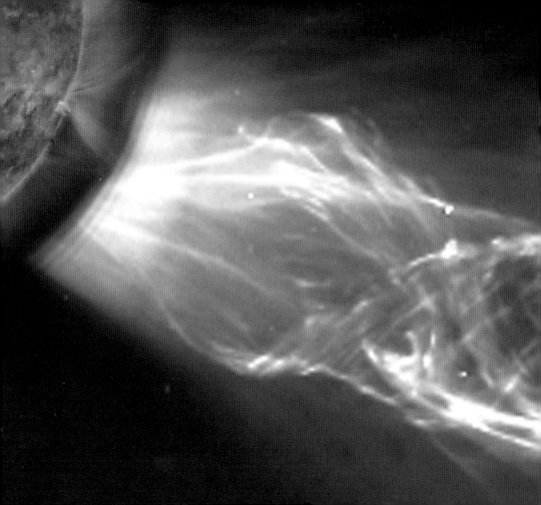

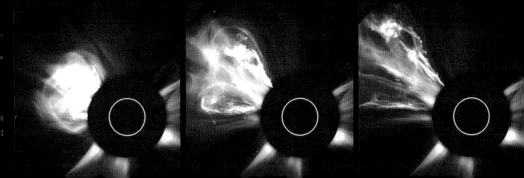

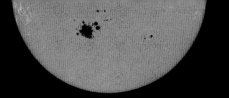

2003/10/28 06:24

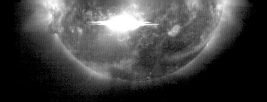

2003/10/28 11:12

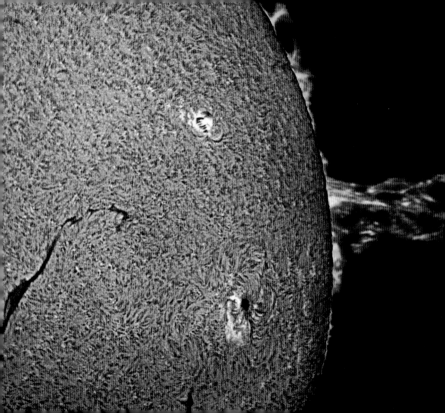

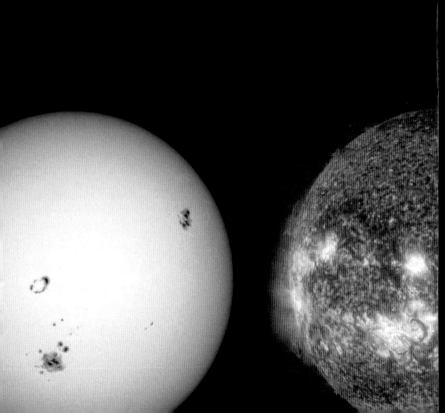

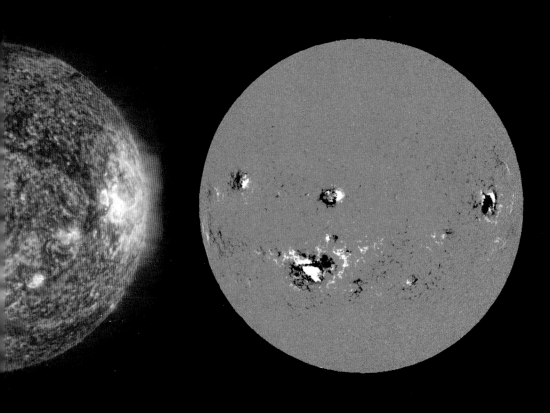

One of the largest sunspots ever observed is captured by a white-light
telescope (left), an extreme ultraviolet imager (center), and a magnetogram
(right) that shows the magnetic activity around the spots.

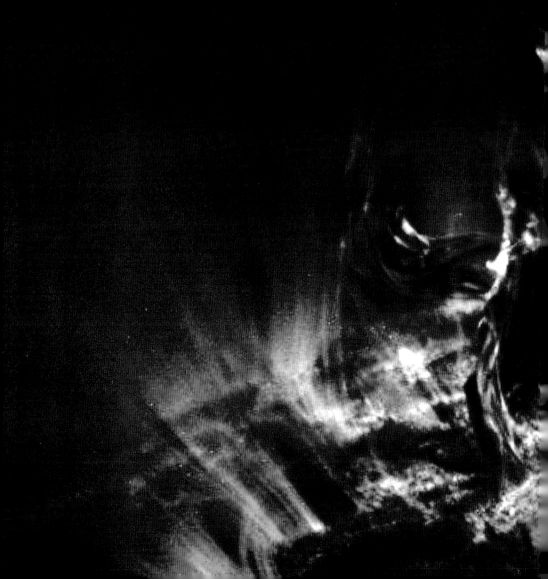

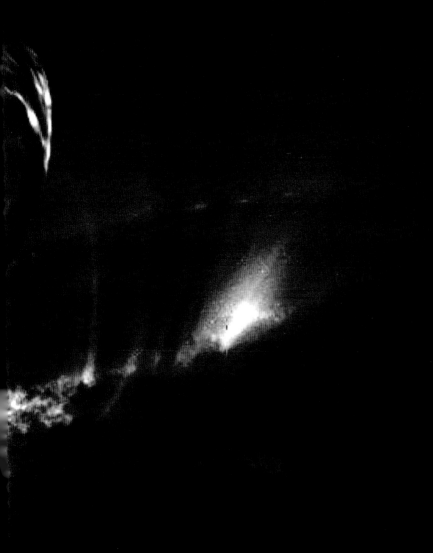

The TRACE satellite captured this close-up of particles being shot out of an active region on the Sun. Wisps of magnetic field flux ropes hang suspended above the intense, bright ultraviolet emissions.

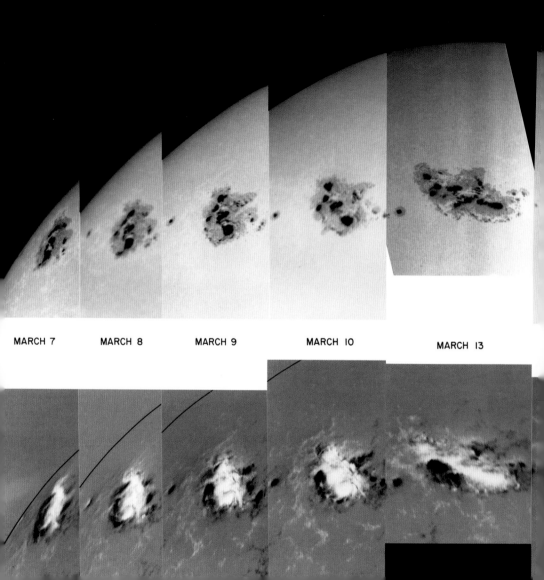

MARCH 7 MARCH 8 MARCH 9 MARCH 10 MARCH 13

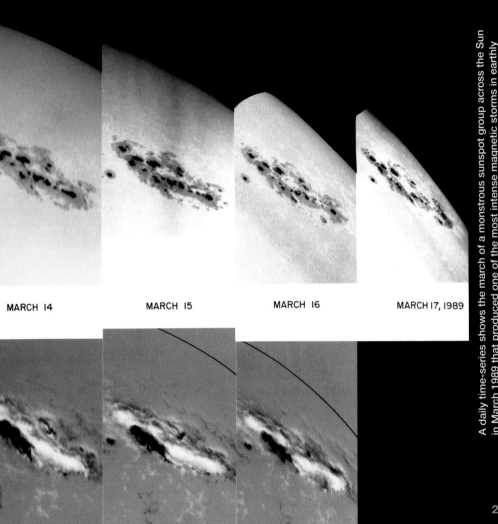

MARCH 14 MARCH 15 MARCH 16 MARCH 17, 1989

A daily time-series shows the march of a monstrous sunspot group across the Sun in March 1989 that produced one of the most intense magnetic storms in earthly history (page 176).

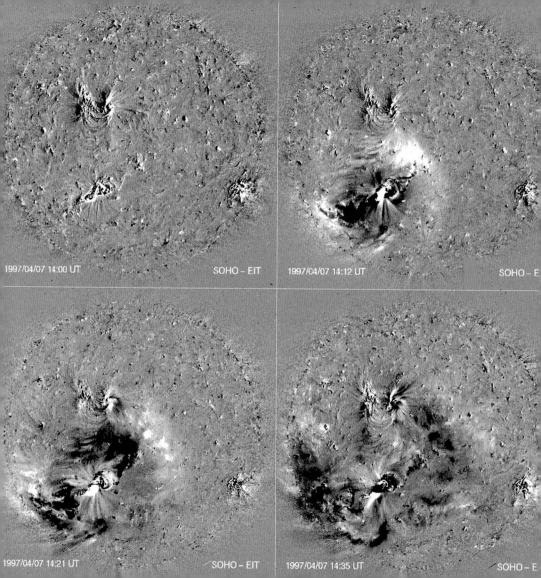

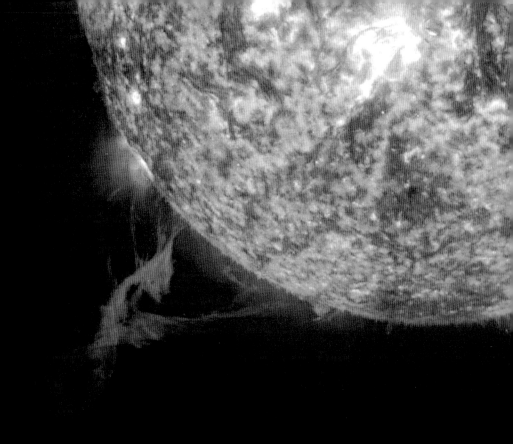

A prominence twists as it breaks away from the Sun on January 18, 2000.

← This series shows the progress of a wave of energy—called a Moreton wave—traveling across the atmosphere of the Sun in less than an hour on April 7, 1997. The "difference images" are produced by comparing sequential images of the Sun's ultraviolet light and highlighting only pixels that changed

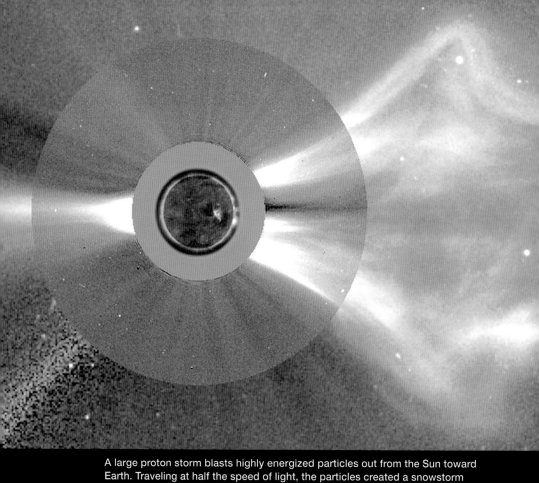

A large proton storm blasts highly energized particles out from the Sun toward Earth. Traveling at half the speed of light, the particles created a snowstorm effect on the SOHO spacecraft's camera within twenty minutes. Such high-energy particles can cripple satellites by causing electrical arcs and by piercing sensitive electronic components.

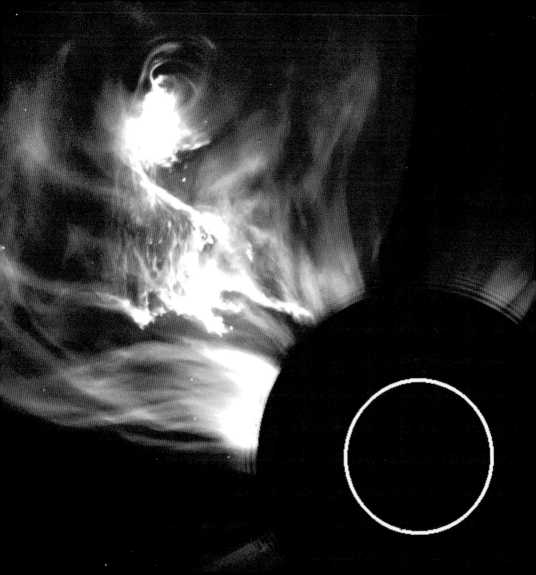

Beyond the Sun

Ah, but a man's reach should exceed his grasp,
Or what's a heaven for?

Robert Browning, "ANDREA DEL SARTO"

An astronaut on STS-82 and the edge of Earth are caught in silhouette by the Sun. Radiation from solar storms poses risks for astronauts.

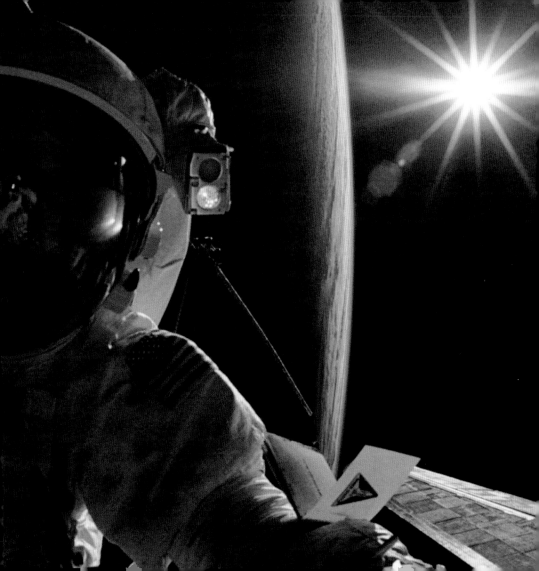

THE REACH OF THE SUN extends well beyond our little planet. At least eight other planets—some would say seven or nine, depending on how you count Pluto and the recently discovered Sedna—are warmed by the Sun's light or tugged by its gravity. A menagerie of other rocks and moons and ice balls circle those planets and the Sun itself. Each has its own relationship with the Sun, as chemistry, physics, and geometry affect the view, the orbit, and the exchange of energy.

When we rise above Earth as astronauts or with robotic satellites, we can see different sorts of sunrises and sets, without the light-filtering prism of earthly air. The perspective broadens, and we see the Sun with all its astronomical children whirling about together on the same disk of the ecliptic plane—the plane of the planets (pages 218–19). From the surface of the Moon and Mars, where the atmosphere is dusty and tenuous—stripped away by the harsh radiation and electrically charged solar wind—the Sun plays on a background of gray, black, or red. We can see the electric lights of auroras curling around the poles of Jupiter, Saturn, Uranus, and Neptune, since each of those planets has a magnetic field and an atmosphere—prerequisites for auroral lights.

Comets jet in from the outer reaches of the solar system, sloughing off dust and ice as they are melted by sunlight. They also spew ions—electrically charged molecules—as the stream of solar wind blows past them at a million miles per hour and creates faint blue and yellow ion tails. Both the dust and ion tails always point away from the Sun—whether the comet is traveling inbound or outbound—as the Sun's light and particles are always pushing outward. Some of these comets—such as the Kreutz sungrazers—meet their demise and get vaporized on their way toward the Sun, a

phenomenon that scientists have watched with awe since the launch of the SOHO satellite in 1995.

With modern telescopic eyes, we can compare our nearest star with its astrophysical brethren and put it in context, seeing it for what it is: one of billions and billions. It is part of the grand family of "main sequence" stars—great gas balls that have grown past the infancy of their birth clouds and have started shining with the chain reactions of nuclear fusion. The Sun is by no means average. The majority of stars are smaller, dimmer, cooler, and less massive. If you measure the Sun against extremes, then it falls somewhere in the middle. But if you measure it within the population of the universe, it is rather large.

From Earth we can see with the naked eye the galaxy in which we reside. We live on one of the outer arms of the Milky Way, and our solar system makes a circuit around the galactic center once every 226 million years. Yet we cannot see the nearest star to our Sun—Proxima Centauri—because it is too dim to view without a telescope.

Is there another star out there like ours, surrounded by life-supporting planets? Do the galaxies and star nurseries shelter another Sun, another Earth? With radio dishes and satellite telescopes, astronomers have intensified their hunt for sunlike stars and extra-solar planets. But it is unlikely we will know for sure until we go out there, and we will likely use the Sun to propel us.

In the seventeenth century, Johannes Kepler first proposed traveling across the void on solar power, though not the kind that we harness today. Every photon of light, moving at 186,000 miles per second, exerts pressure. That force is just enough to push a "light sail" across the solar system, just as the wind catches canvas sails down here on Earth. Arthur C. Clarke, Carl Sagan,

and other visionaries have daydreamed about sailing on sunbeams, and in recent years, scientists and engineers have been turning the dream into reality.

New spacecraft are being designed to harness this power (page 233). Blown by the forceful energy of sunlight, a solar sailing vessel could accelerate continuously, reaching speeds never attainable with rockets. Specialized membrane mirrors—some as thin as a human hair—would gather thrust from photons. The energy supply is free and never-ending, and the potential is enormous. Engineers are betting that it might be just the right fuel to carry us beyond our star's grasp and on to another galaxy . . . in search of another Sun.

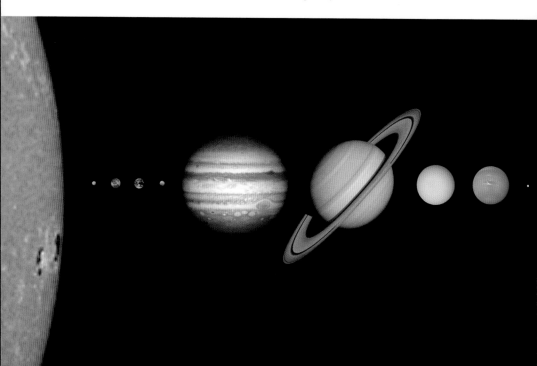

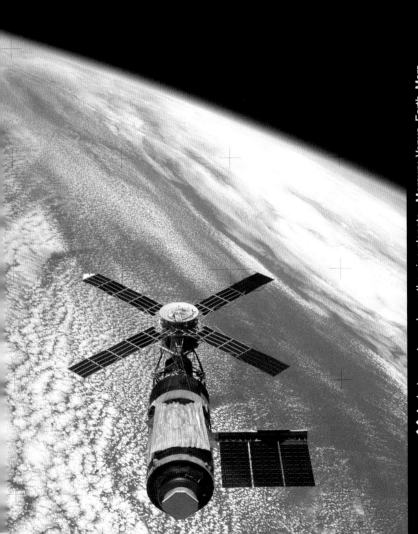

↑↑ A photo montage shows the nine planets—Mercury, Venus, Earth, Mars, Jupiter, Saturn, Uranus, Neptune, and Pluto—lined up in order and shown in their relative size to each other. Our star comprises 99 percent of the mass of the solar system, and all of the planets could easily fit inside.

↑ Launched in May 1973, Skylab was the United States' first manned space station and an early attempt to harness solar power for space flight. This scientific mission included some of the first high-resolution observations of the Sun made without the murky filter of Earth's atmosphere.

Looking down from the International Space Station in June 2001, astronauts observed the day-night terminator—the transition between day, night, and twilight as Earth rotates into sunlight. The clouds take on reddish hues as sunlight filters through the dust and gas of the atmosphere.

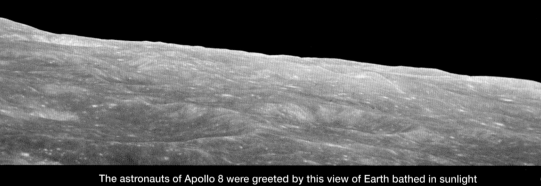

The astronauts of Apollo 8 were greeted by this view of Earth bathed in sunlight in December 1968. This earthrise occurred as the spacecraft returned from the dark side after the first human voyage around the Moon.

→ The harsh glare of the Sun illuminates the tracks of the two-wheeled Modularized Equipment Transporter across the lunar soil after the Apollo 14 astronauts made their first venture out of the spacecraft in February 1971. The lunar module Antares lurks in the distance.

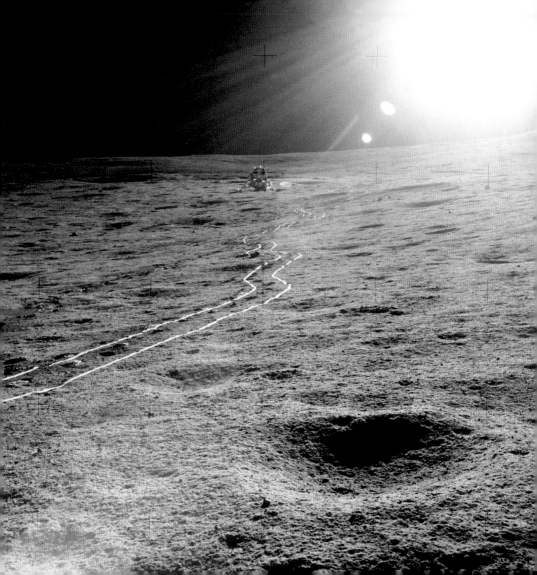

In 1994, the Clementine spacecraft snapped this photo of the Sun's corona reaching over the limb of the Moon. The image also shows the ecliptic, or plane, of the planets. Saturn, Mars, and Mercury (from left to right) lie at different distances from the Sun, but all move around it in the same imaginary, horizontal plane as Earth. In this image, the Moon is lit by earthshine—the reflection of sunlight from Earth back into space.

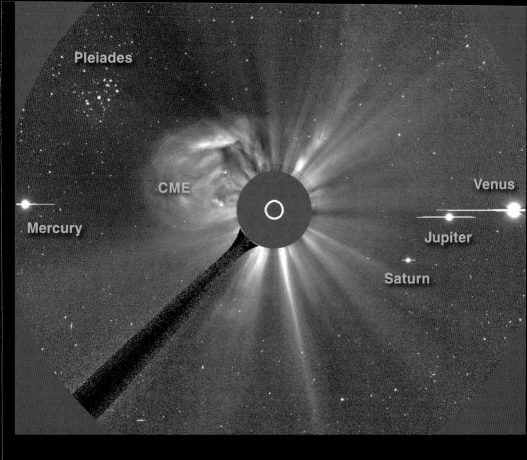

The SOHO satellite, which orbits one million miles from Earth, captured this rare view of the Sun, four planets, and the Pleiades star cluster—the "seven sisters"—in the same patch of sky on May 15, 2000. By coincidence, a CME erupts off from the western limb of the Sun.

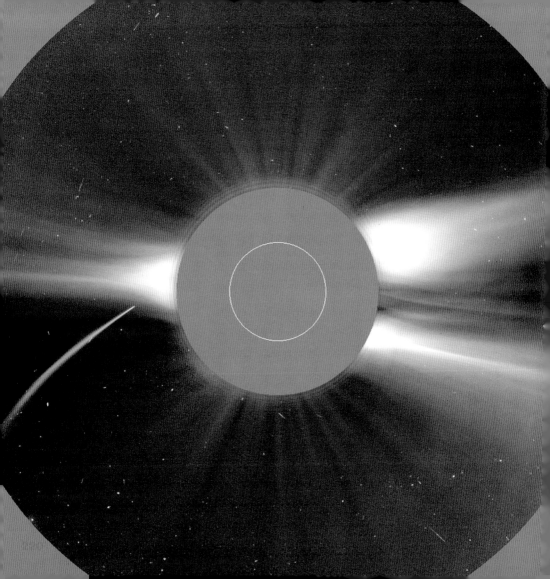

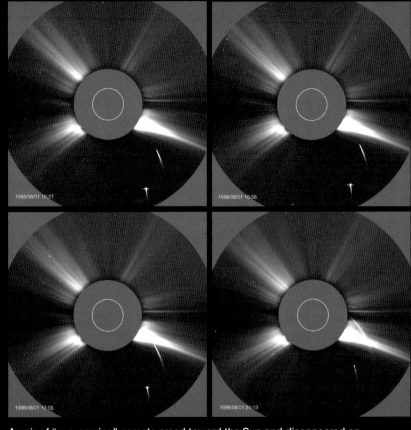

A pair of "sun-grazing" comets arced toward the Sun and disappeared on June 3, 1998. They were likely vaporized as they flew too close to the star. The SOHO satellite has observed more comets (1,000 and counting) than any other astronomer or telescope in history.

← Like a Fourth of July bottle rocket, a comet streaks toward the Sun in December 1996. The heat and pressure of sunlight vaporized the comet shortly after this image was captured.

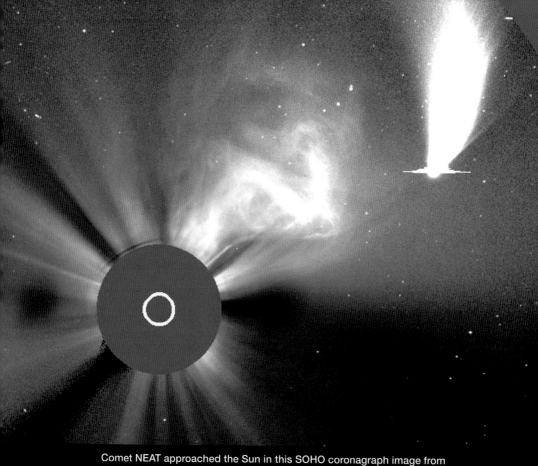

Comet NEAT approached the Sun in this SOHO coronagraph image from February 2003. A CME blows out in the same general direction.

→ A close-up of comet Hale-Bopp from 1997 reveals a long white tail of dust and water being burned off by the heat and pressure of sunlight. The blue tail is made of ions—charged atomic particles—being sloughed off from the comet by

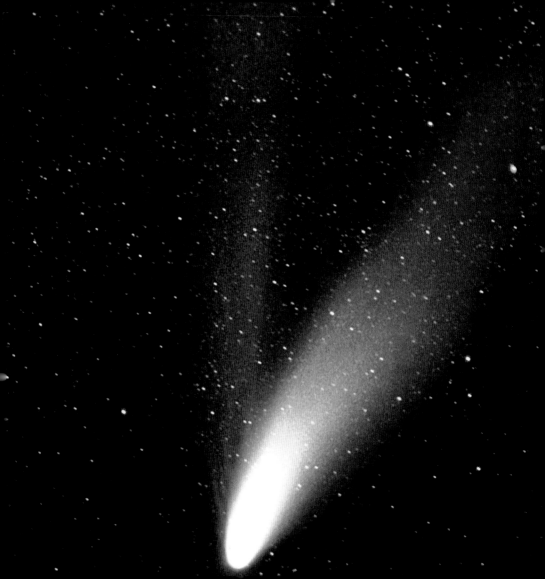

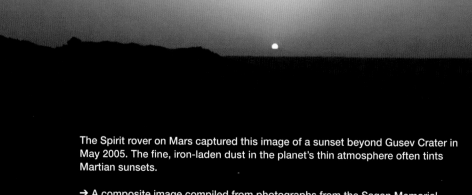

The Spirit rover on Mars captured this image of a sunset beyond Gusev Crater in May 2005. The fine, iron-laden dust in the planet's thin atmosphere often tints Martian sunsets.

→ A composite image compiled from photographs from the Sagan Memorial Station and the Mars Pathfinder mission reveals the Martian analemma—the position of the Sun as it changes angles in the planet's sky throughout the year. Compare it with Earth's analemma on page 75.

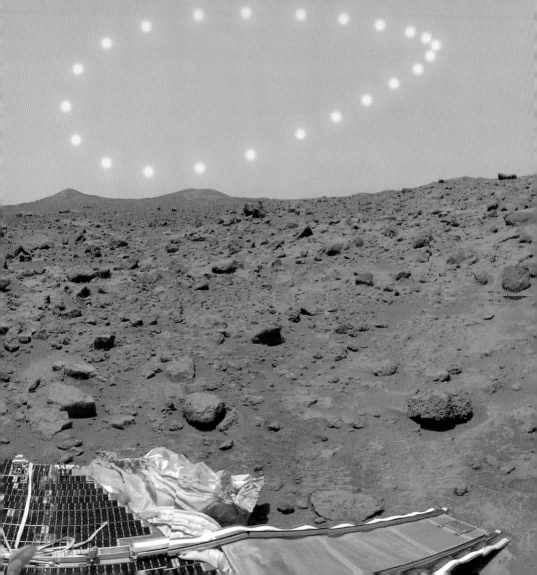

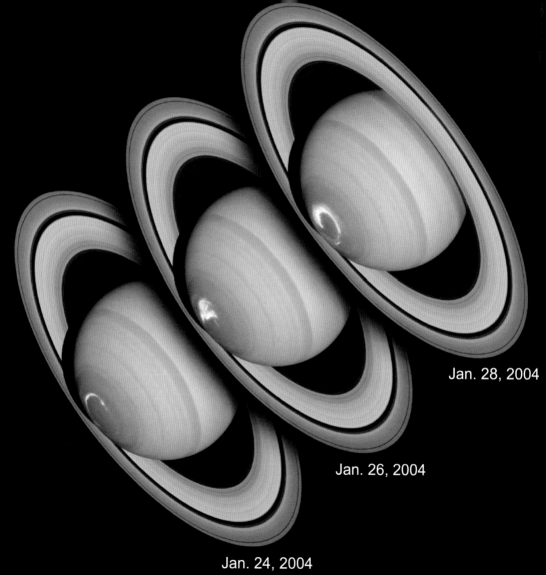

Jan. 28, 2004

Jan. 26, 2004

Jan. 24, 2004

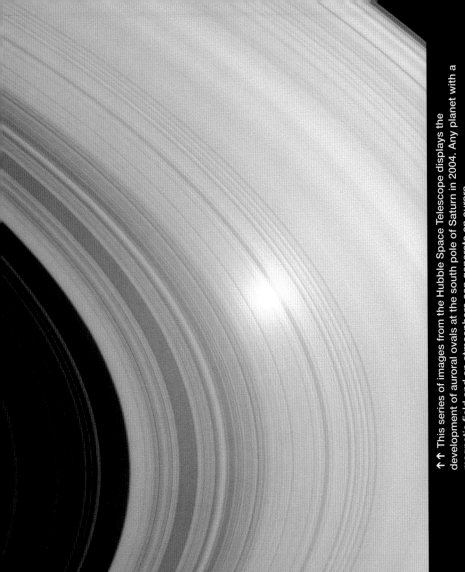

↑↑ This series of images from the Hubble Space Telescope displays the development of auroral ovals at the south pole of Saturn in 2004. Any planet with a magnetic field and an atmosphere can generate an aurora.

↑ The Cassini spacecraft captured this view of the Sun reflected in Saturn's rings in June 2005. This "opposition effect" occurs when the sun is directly behind the spacecraft, and it is similar to the halos in a Brocken spectre (see page 62).

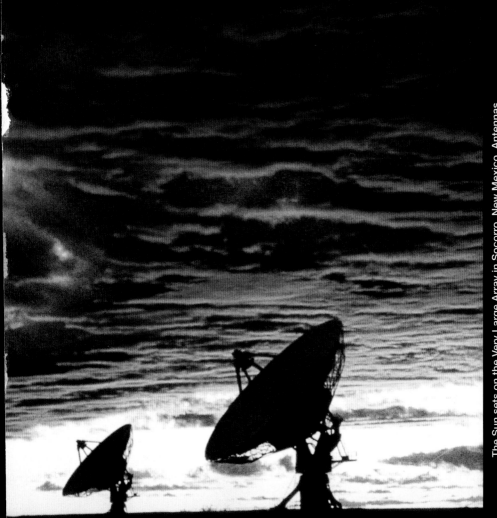

The Sun sets on the Very Large Array in Socorro, New Mexico. Antennas constantly scan the skies for radio emissions from other stars, galaxies, quasars, and astronomical objects.

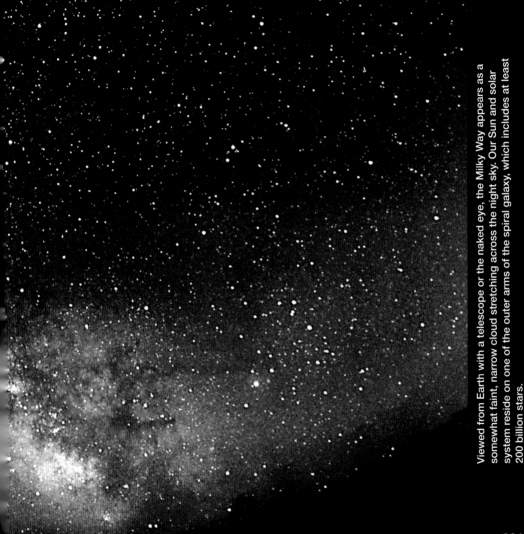

Viewed from Earth with a telescope or the naked eye, the Milky Way appears as a somewhat faint, narrow cloud stretching across the night sky. Our Sun and solar system reside on one of the outer arms of the spiral galaxy, which includes at least 200 billion stars.

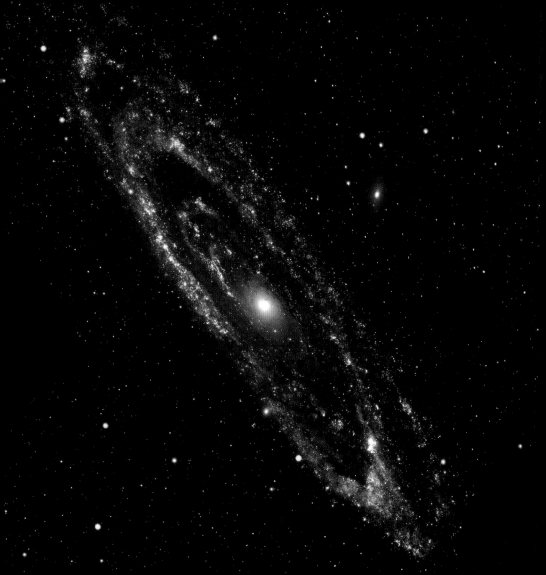

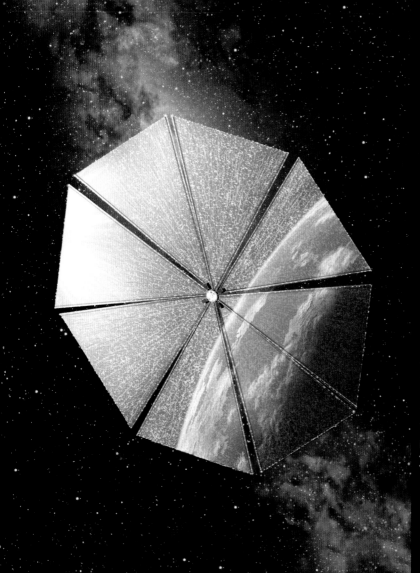

↑ ↑ The Andromeda Galaxy is a spiral similar to our own. It is the nearest major galaxy to our Sun and the largest in our universal neighborhood.

↑ An artist created this view of how a solar sailing craft might look after it stretches its gossamer wings. The first solar-sail film was launched into space by the Japan Aerospace Exploration Agency in August 2004, while the U.S.-based Planetary Society attempted a private launch of the first complete solar sailing vehicle, *Cosmos 1*, in June 2005.

233

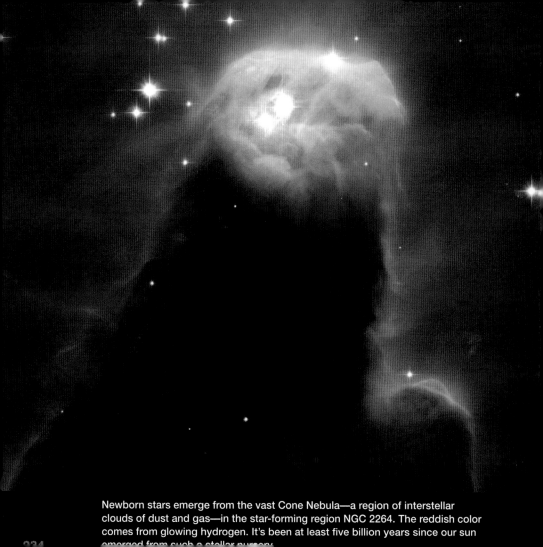

Newborn stars emerge from the vast Cone Nebula—a region of interstellar clouds of dust and gas—in the star-forming region NGC 2264. The reddish color comes from glowing hydrogen. It's been at least five billion years since our sun emerged from such a stellar nursery.

In Print

Michael J. Carlowicz and Ramon E. Lopez, *Storms from the Sun* (The Joseph Henry Press, 2002).

Stephen P. Maran, *Astronomy for Dummies* (IDG Books Worldwide, 2000).

Robert J. Nemiroff and Jerry T. Bonnell, *The Universe: 365 Days* (Harry N. Abrams, 2003).

Mark Littmann, Ken Wilcox, and Fred Espenak, *Totality: Eclipses of the Sun* (Oxford University Press, 1999).

Syun-Ichi Akasofu, *Secrets of the Aurora Borealis* (Alaska Geographic Society, 2002).

On the Web

SOHO—The Solar and Heliospheric Observatory
sohowww.nascom.nasa.gov

Storms from the Sun
www.stormsfromthesun.net

Astronomy Picture of the Day
antwrp.gsfc.nasa.gov/apod

National Solar Observatory
www.nso.edu

High Altitude Observatory
www.hao.ucar.edu/Public/education/education.html

Sun-Earth Day
www.sunearthday.nasa.gov

Chris Linder Photography
www.chrislinder.com

Lauri Kangas Photography
www.photon-echoes.com

Jan Curtis's Images of the Aurora
http://climate.gi.alaska.edu/Curtis/curtis.html

Atmospheric Optics
www.sundog.clara.co.uk/atoptics/phenom.htm

Earth-Sun Science at NASA
science.hq.nasa.gov/earth-sun/index.html

Windows to the Universe
www.windows.ucar.edu/windows.html

From Stargazers to Starships
www.phy6.org/stargaze/Sintro.htm

The Stanford Solar Center—Folklore
solar-center.stanford.edu/folklore

www.spaceweather.com

www.mreclipse.com

Photo Credits

Steve Albers, Dennis di Cicco, and Gary Emerson: page 95
Anthony Ayiomamitis: page 75
Sylvie Beland: page 110
Ruth Benn: page 102
Big Bear Solar Observatory, NJIT: pages 162, 181
Reproduced from The Norwegian Aurora Polaris Expedition, 1902-1903 by Kristian Birkeland: page 119
Dominic Cantin: pages 2-3, 230-31
Michael Carlowicz: page 66
Centre National d'Etudes Spatiales/ESA: page 109
Clayton Hogen-Chin: page 45
Troy Cline, NASA: pages 81, 86-88
Jan Curtis: pages 13, 115, 123, 125, 129
Arne Danielsen: page 97
Guillaume Dargaud: pages 64, 76-77
Jack Eddy: page 90
Thomas Eklund: pages 72-73
Fred Espenak: pages 94, 99
Dave Finley, National Radio Astronomy Observatory, Associated Universities Inc./NSF: pages 228-29
Gosport Borough Council, UK: page 91
High Altitude Observatory, University Corporation for Atmospheric Research: page 163
Steele Hill, SOHO, NASA/ESA: pages 17, 112, 155, 180
History of Science Collections, University of Oklahoma Libraries: pages 104, 107
Hubble Space Telescope, STSCi, NASA: pages 232, 234
Dick Hutchinson: page 21
Julie Deth-Rhoden Hutto: page 51
Einar Johnskas: page 122
Grant Johnson: page 36
Johnson Space Center/NASA: pages 1,

4-5, 7, 56-57, 108, 133-38, 143, 208, 209, 214-17
Lauri Kangas: pages 12, 20, 27, 31, 33, 34, 55, 61, 65, 67, 71
Jan Koeman: page 113
Chris Linder: pages 9, 18, 28-30, 32, 35, 37-39, 42, 43, 48, 59
Lockheed Martin Solar and Atmospheric laboratory/TRACE/NASA: pages 111 (bottom), 149, 165, 168-70, 200-01
Shawn Lowe: pages 10, 63
Lunar and Planetary Institute (adapted from): page 212
Dennis Mammana: pages 46-47, 98, 103, 120-21, 225
Mars Exploration Rover Mission, Texas A&M, Cornell, JPL, NASA: page 224
Rita Moore: page 105
NASA: pages 213, 218
NASA/ESA, J. Clarke (Boston University), and Z. Levay (STScI): page 226
National Oceanic and Atmospheric Administration/AURA/NSF: pages 202-03
National Oceanic and Atmospheric Administration Library Collection: page 16
National Optical Astronomy Observatory: page 100
National Solar Observatory/Sacramento Peak, NOAO: page 19
Jack Newton: page 167
Eric Nguyen/Jim Reed Photography: page 58
Gary Palmer: pages 160, 197
Pekka Parviainen: page 23, 60, 68-70, 78-79, 132 (bottom)
Don Pettit, NASA: page 132 (top)
Philosophical Transactions of the Royal Society of London: page 106
Alexander Pikhard: page 14

POISE, National Optical Astronomy Observatory: page 152
Jim Saige/Mt. Washington Observatory, NH: page 62
Skylab, NASA: pages 158, 213
SOHO, NASA/ESA: pages 11, 15, 111(top), 147, 148, 151, 153, 154, 156, 159, 161, 164, 166, 174, 179, 182, 183, 186-96, 198-99, 204-07, 219-22
Sigurdur Stefnisson: pages 40-41, 126-28
Space Science Institute, JPL, NASA: page 227
Rick Sternbach, The Planetary Society: page 233
Stock Photo, NASA: page 85
Swedish Solar Telescope, Institute for Solar Physics: pages 171-73
Chris Tanz: page 89
Michel Tournay: pages 44, 124, 130-31
Neil deGrasse Tyson: page 49
Cherie Ude: page 74
University of California Regents/Lick Observatory: page 72
University of Iowa/NASA: pages 139, 140
USAF Defense Meteorological Satellite Program: page 141
Reproduced from G. De Vaucouleurs, Astronomical Photography, MacMillan, 1961: page 93
Vic Winter: pages 96, 101, 223
Yohkoh/Institute for Space and Astronautical Science/NASA: pages 150, 157, 184

Our voyage to the Sun began eight years ago when we shared an office at NASA's Goddard Space Flight Center. Day after day, we traded ideas and images that could engage and educate the public about our nearest star. We watched the Sun and the aurora alongside the scientists of the SOHO and the International Solar-Terrestrial Physics program, learning as they learned, discovering as they discovered.

It was a rare privilege for a couple of liberal arts majors to be part of the greatest solar observing campaign in history. We collaborated on posters, web pages, press releases, and educational products, but none of them did justice to the amazing views of the Sun we were seeing. Hence this book, which attempts to bring together the full breadth of solar imagery from the ancient to the edge of the future.

We owe our gratitude to our agent, Skip Barker, who helped focus our ideas and work through the rollercoaster ride of collaboration. Thanks also to our editors, Eric Himmel and Andrea Danese of Harry N. Abrams, who saw the promise in our proposal and helped shape the book in ways we never could have envisioned. Our designer, Darilyn Carnes, and Shawn Dahl, both at Abrams, brought watchful and creative eyes to the text and layout.

We would not have a book if not for the generous contributions of many photographers, amateur and professional, who shared their work for the sheer love of the light of the Sun. We are particularly indebted to Chris Linder, Lauri Kangas, Jan Curtis, and Dennis Mammana. We also wish to thank Joe Gurman, project scientist for SOHO, and our many other friends at NASA, the European Space Agency, and other research institutions who helped us gather a terrific collection of taxpayer-funded images.

Books don't get created without muses, and we are indebted to our wives, Gail and Florence, for their encouragement, patience, and insight. We also thank our children and parents for their inspiration.

Editor: Andrea Danese
Designer: Darilyn Lowe Carnes assisted by Shawn Dahl
Production Manager: Maria Pia Gramaglia

Library of Congress Cataloging-in-Publication Data

Hill, Steele.
 The sun / by Steele Hill and Michael Carlowicz.
 p. cm.
 Includes bibliographical references and index.
 ISBN 13: 978-0-8109-5522-6
 ISBN 10: 0-8109-5522-9 (hardcover : alk. paper)
1. Sun. I. Carlowicz, Michael J. II. Title.
QB521.H55 2006
523.7—dc22

 2005027512

Copyright © 2006 Steele Hill and Michael Carlowicz

Published in 2006 by Abrams, an imprint of Harry N. Abrams, Inc.
All rights reserved. No portion of this book may be reproduced,
stored in a retrieval system, or transmitted in any form or by any means,
mechanical, electronic, photocopying, recording, or otherwise,
without written permission from the publisher.

Printed and bound in China
10 9 8 7 6 5 4 3 2

HNA ▰▰▰▰▰
harry n. abrams, inc.
a subsidiary of La Martinière Groupe

115 West 18th Street
New York, NY 10011
www.hnabooks.com

Page 1
Sunrise, as viewed from the space shuttle
Endeavour in June 2002, illuminates
Earth's thin blue atmosphere.

Pages 2–3
Sunset in Quebec.

Pages 4–5
The Sun reflects off the cloud tops and
the Pacific Ocean, as viewed from the
International Space Station.

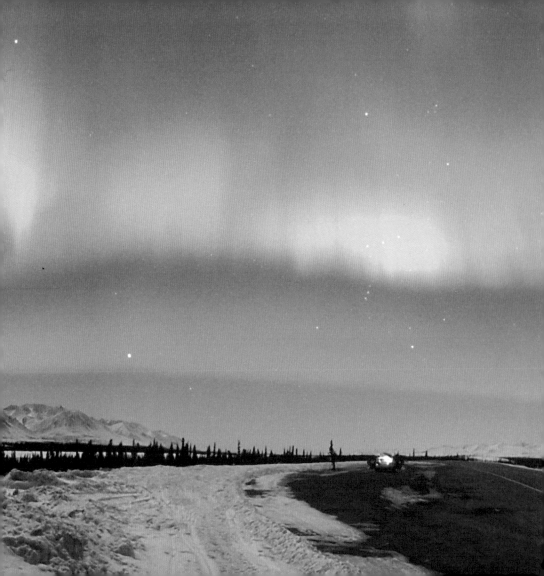